NAGARYA
Part 2 "The Lost Continent"

Art & Story by Riverstone

PRIAPRISM PRESS

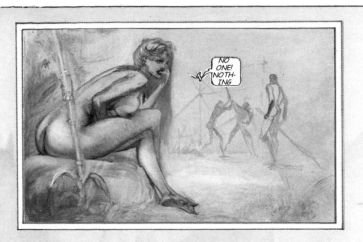

NO ONE! NOTH- ING

FINALLY, AFTER ALL THIS TIME WASTED IN WAITING, EVENTS STARTED UNFOLDING... ON THE BANKS OF THE LOST CONTINENT.

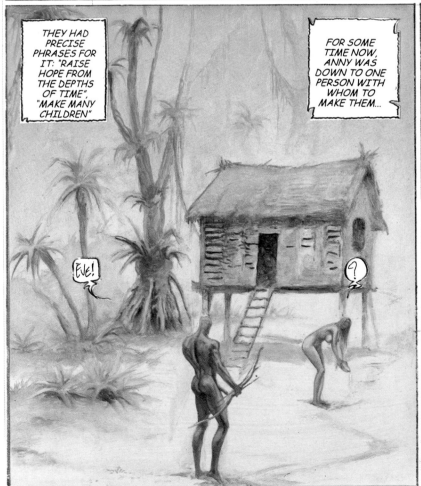

THEY HAD PRECISE PHRASES FOR IT: "RAISE HOPE FROM THE DEPTHS OF TIME", "MAKE MANY CHILDREN"

FOR SOME TIME NOW, ANNY WAS DOWN TO ONE PERSON WITH WHOM TO MAKE THEM...

EVE!

?

FLEE FAR AWAY FROM US!

WHY SHOULD I? YOU'RE THE ONLY ONE I HAVE! LET THINGS EVOLVE!

JOHNNY...

WHOM SHOULD I START WITH? I DON'T WANT TO KNOW... THINGS ARE SO HEAVY!

ANNY, I WILL TELL YOU A SECRET!

HE TOLD HER OF A TEMPLE BUILT HAPHAZARDLY BY MEN NEAR THE SOURCE OF THE RIVER...

SHE WANTED TO SEE IT FOR HERSELF..

2

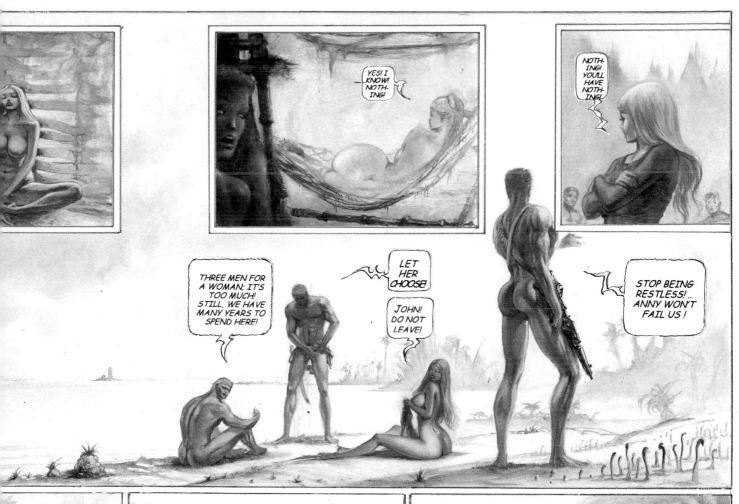

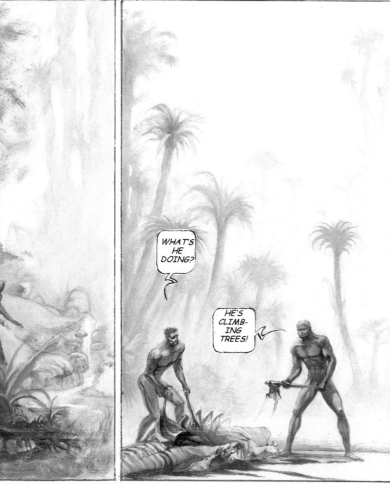

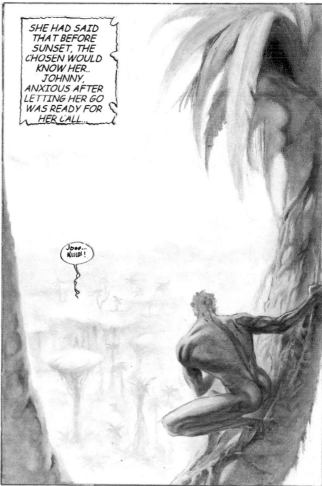

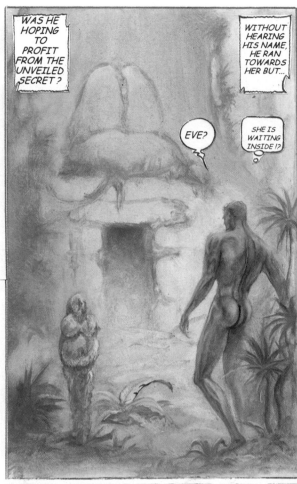

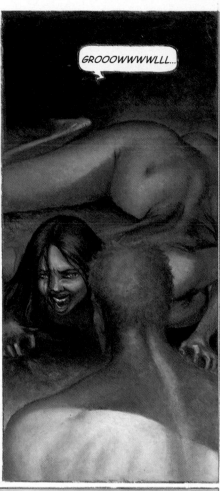

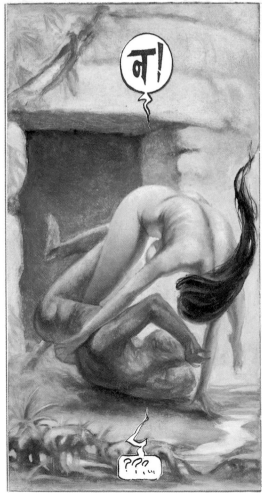

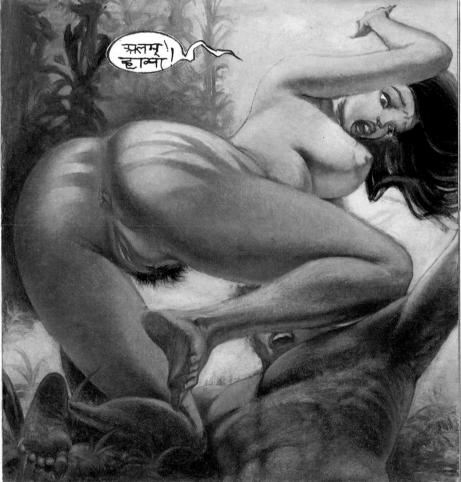

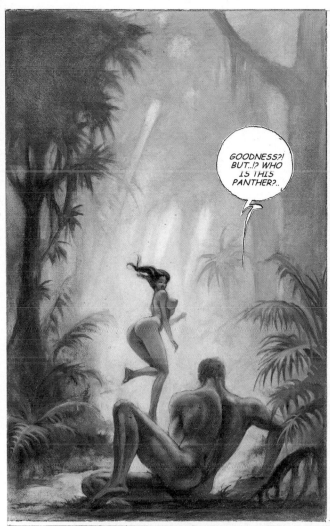

GOODNESS?! BUT..!? WHO IS THIS PANTHER?..

HEY!! WAIT!!..

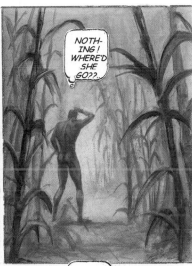

NOTH- ING! WHERE'D SHE GO??..

I COULD HAVE SWORN...

HEY!

NOTHING! AT ALL! SHE'S GONE!

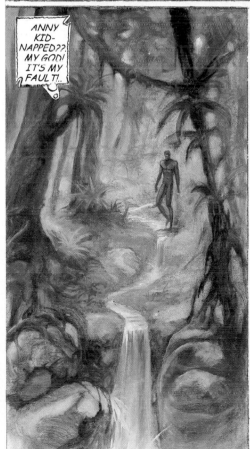

ANNY KID- NAPPED?? MY GOD! IT'S MY FAULT!..

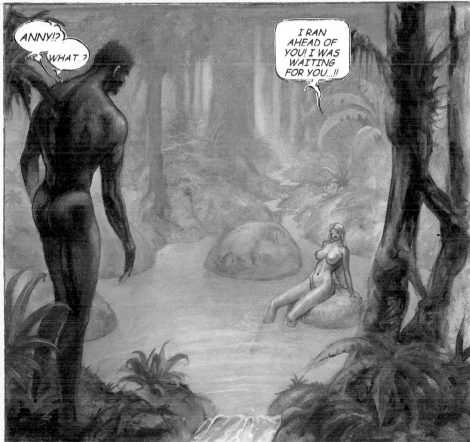

ANNY!? WHAT ?

I RAN AHEAD OF YOU! I WAS WAITING FOR YOU...!!

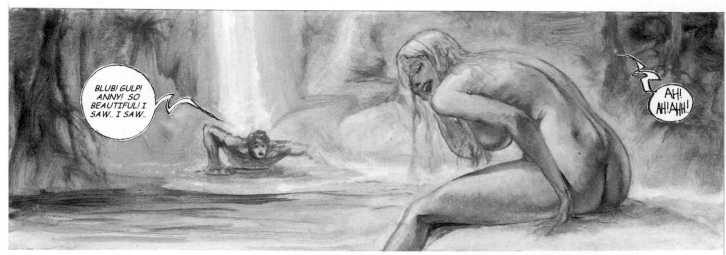

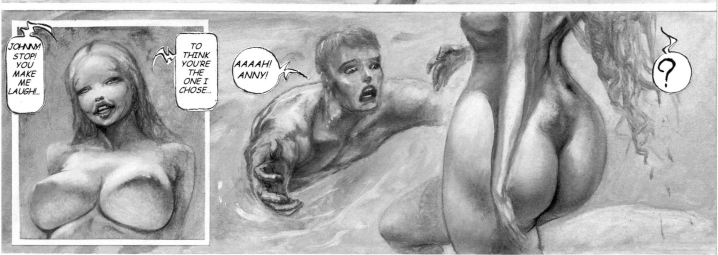

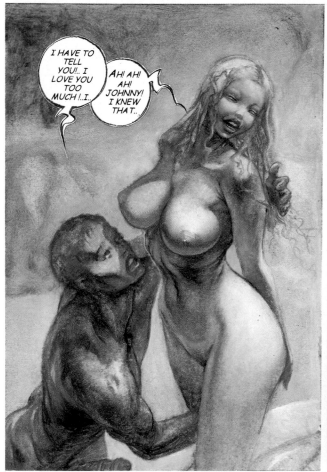

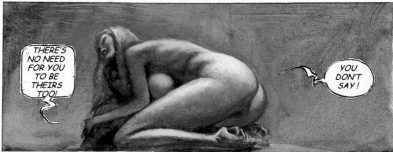

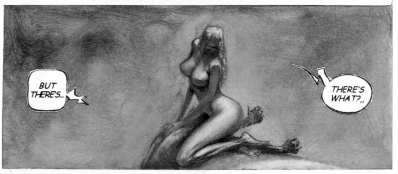

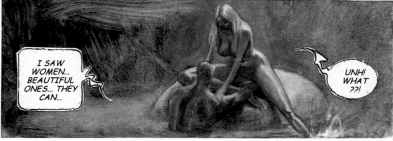

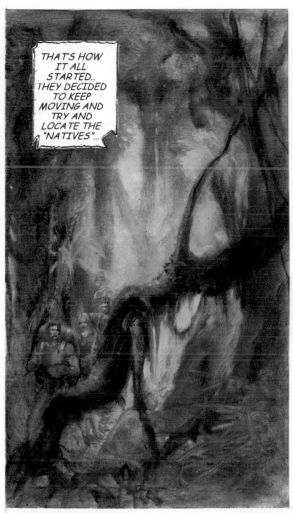

THAT'S HOW IT ALL STARTED.. THEY DECIDED TO KEEP MOVING AND TRY AND LOCATE THE "NATIVES"...

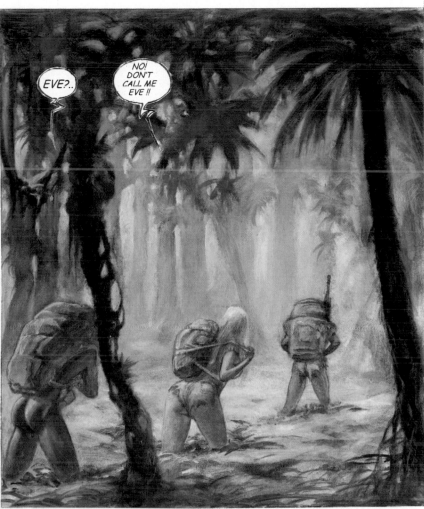

EVE?..

NO! DON'T CALL ME EVE !!

OUCH! I'M SLIPPING!

EEECH!! THIS STUFF! WHAT IS IT?

NO! THIS IS NOT FROM AN ANIMAL!..

IT SMELLS STRONG! IT IS FRESH!

INDEED, ANNY BRINGS US LUCK! THIS IS EXACTLY WHAT WE'RE LOOKING FOR!

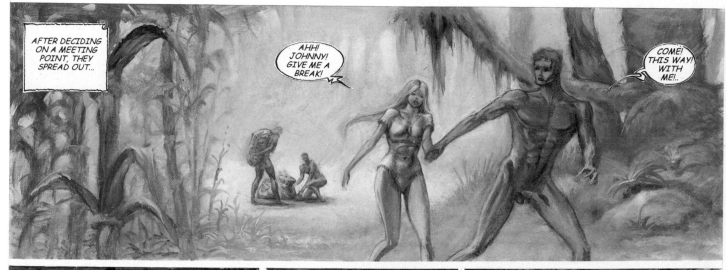

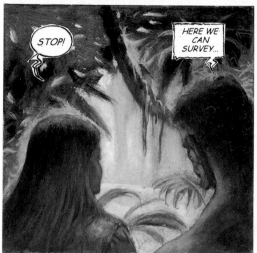

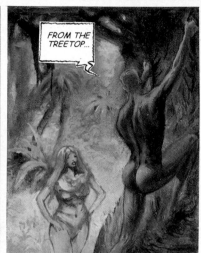

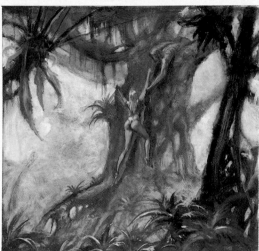

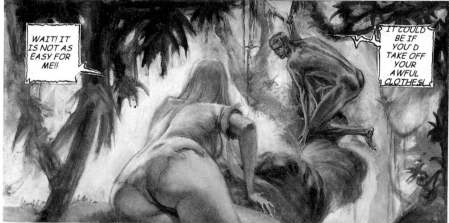

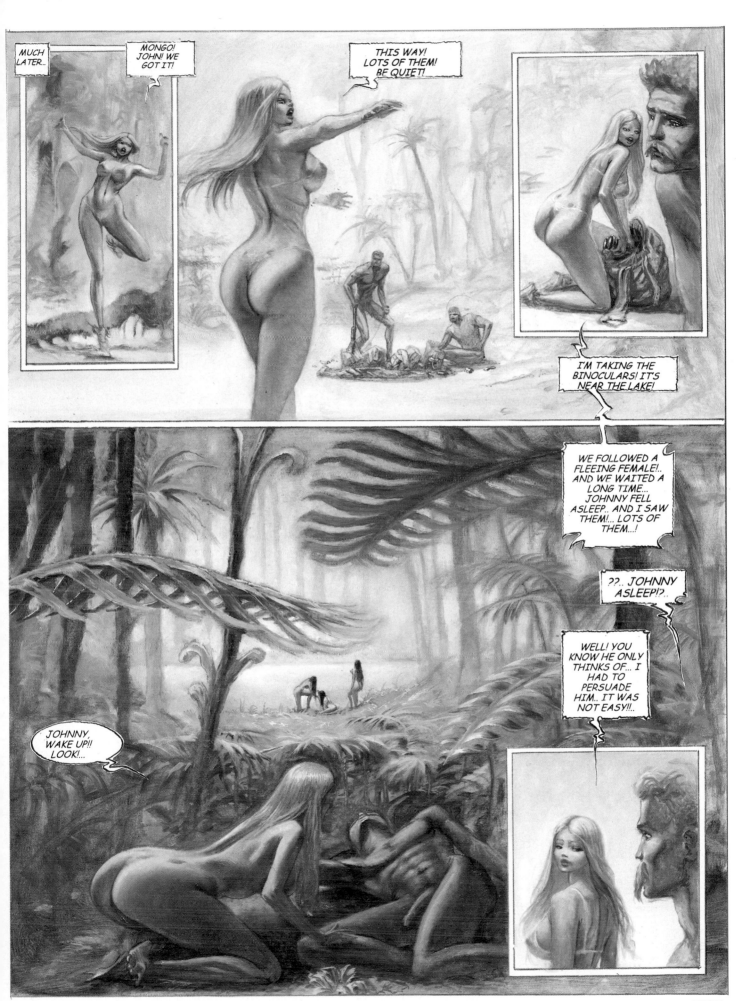

STARTING THAT DAY, THEY FOLLOWED THE NATIVES. ANNY KEPT A DIARY.

DAY 135: .. AFTER A VOTE OF 2 AGAINST 2 (JOHN & ME THE ETHNOLOGIST), WE DECIDED TO OBSERVE THE NATIVES BEFORE ATTEMPTING ANY CONTACT. WE NOTICED THAT THEY ARE EXTREMELY WILD. THEY FLEE THE SLIGHTEST DISTURBANCE AS THOUGH THEY WANT TO AVOID ANY POSSIBLE DANGER. NOTHING IN THEIR IMMEDIATE SURROUNDINGS WOULD JUSTIFY SUCH AN ATTITUDE SINCE THEY DO NOT SEEM TO FEAR THE BIG REPTILES...

DAY 140: DAMPNESS DEGRADES MY NOTEPAD IN SPITE OF THE CARE I TOOK TO PROTECT IT DURING THE "PARADISE" PERIOD (JOHNNY'S WORDS) THE NATIVES ARE HARD TO FOLLOW, THEY'RE ALWAYS ON THE MOVE. IT IS ALSO HARD TO REMAIN CONCEALED AS THEY SPREAD UNEXPECTEDLY IN ALL DIRECTIONS. AND SO THEY ARE HARD TO LOCATE ESPECIALLY SINCE JOHNNY CREATES INCIDENTS SO THEY'LL FLEE...

DAY 145: MONGO WHO EXPECTS TO EMPATHIZE WITH NATIVE FEMALES ALMOST FOUGHT WITH JOHNNY.. THE NATIVES ARE MAINLY PEACEFUL AND SOMETIMES LASCIVIOUS... STILL MOMENTS OF APPARENT DREAD, SILENT AND MOTIONLESS ALL THROUGH THEIR DAY. THEN THEY ACT LIKE STALKING FELINES; IT IS VERY HARD NOT TO COME FACE TO FACE WITH THEM.. WHICH COULD BE DANGEROUS... JOHN SAW A MALE AND HE SAYS HE WAS COLOSSAL...

DAY 151: THESE PEOPLE LIVE LIKE ANIMALS. THEY DON'T BUILD ANYTHING, LEAVE NO TRACES. SOMETIMES THEY SEEM TO CONCENTRATE ON A DANGER THAT WE CANNOT DETECT.. STILL I AM CONVINCED THAT WE ARE NOT THE CAUSE OF THIS TENSION. THEY SEEM TO BE FUGITIVES HAPPY TO BE AWAY FROM EVERYTHING... HAPPY TO SPEND THEIR TIME DOING NOTHING.. THESE INTUITIONS HAVE TO BE VERIFIED..

DAY 159: .. JOHNNY WAS ASLEEP AND WAS DISCOVERED BY A GAGGLE OF FEMALES. THEY DID NOT FLEE. AS HE DID NOT MOVE, THEY OBSERVED HIM SILENTLY AND MOTIONLESSLY. HE WOKE UP BUT FAKED SLUMBER, HE FELT HANDS ON HIM... AND THEN THEY LEFT, LIKE THAT... IT PROVES THEY ARE NOT SCARED OF US... MY INTUITIONS WERE RIGHT.

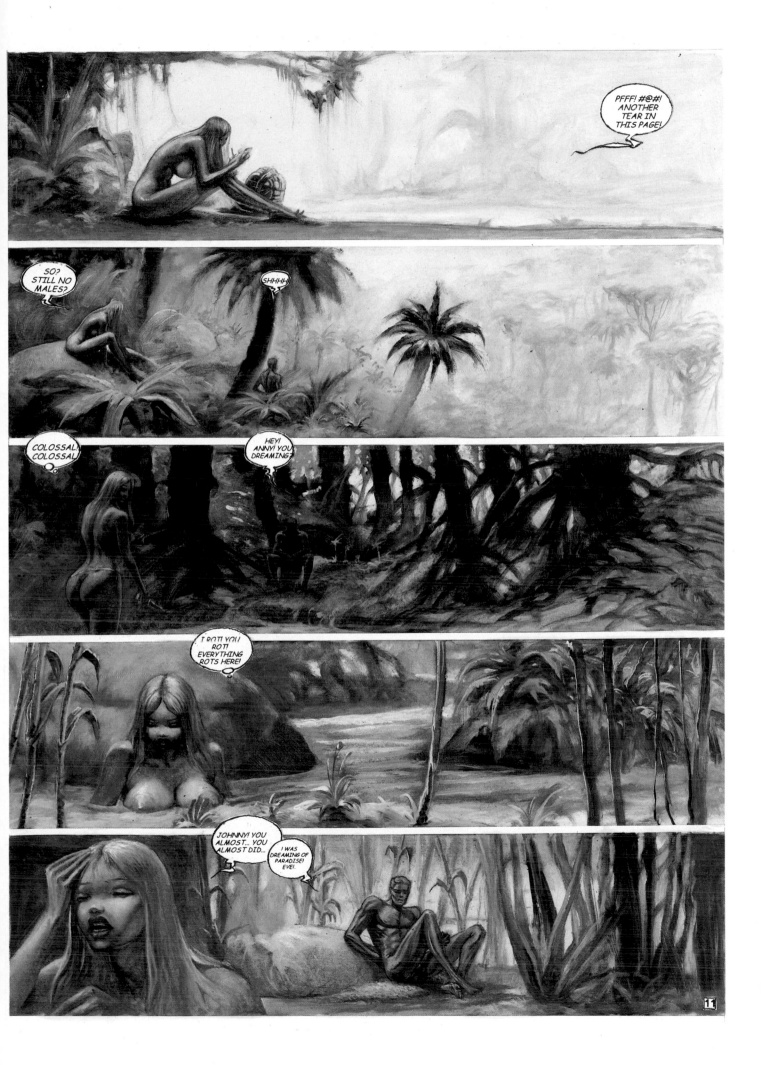

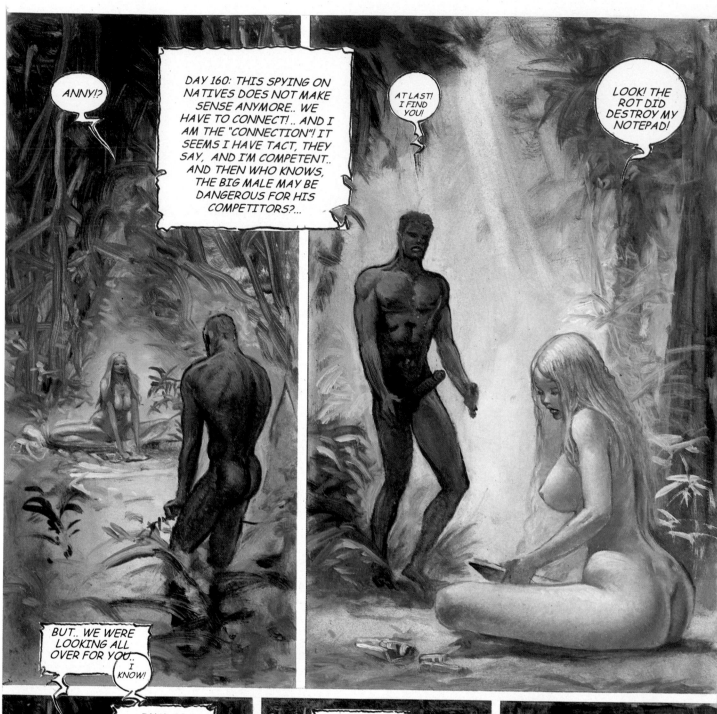

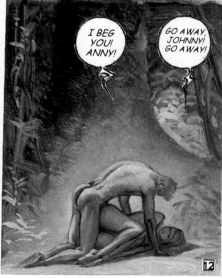

12

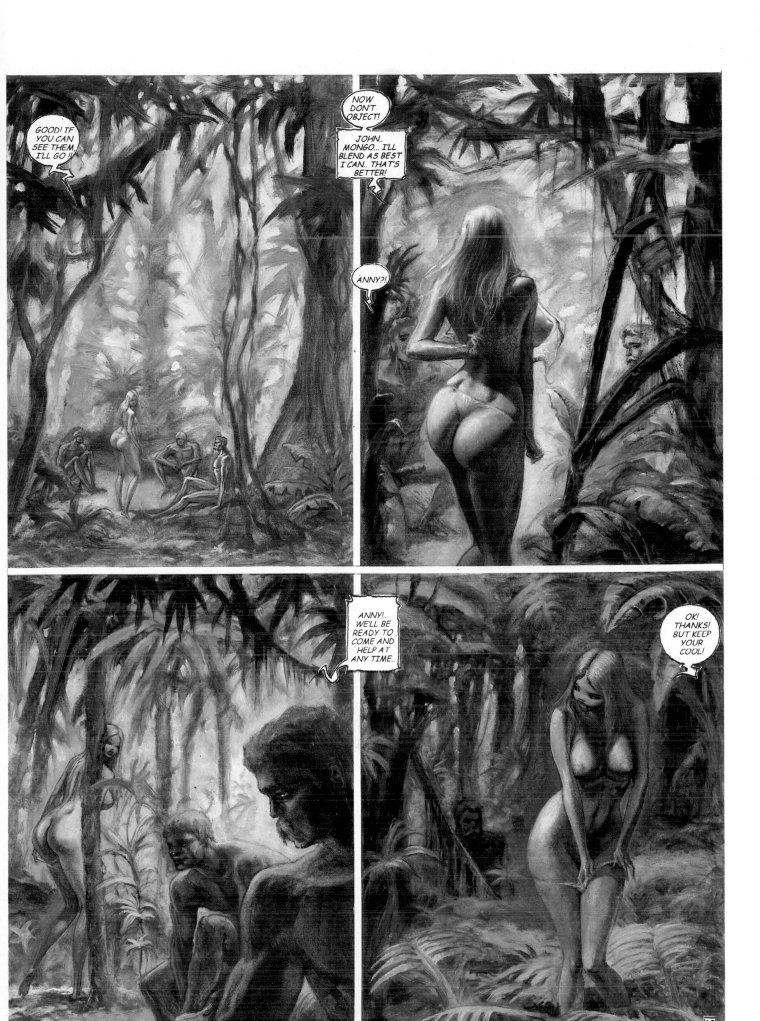

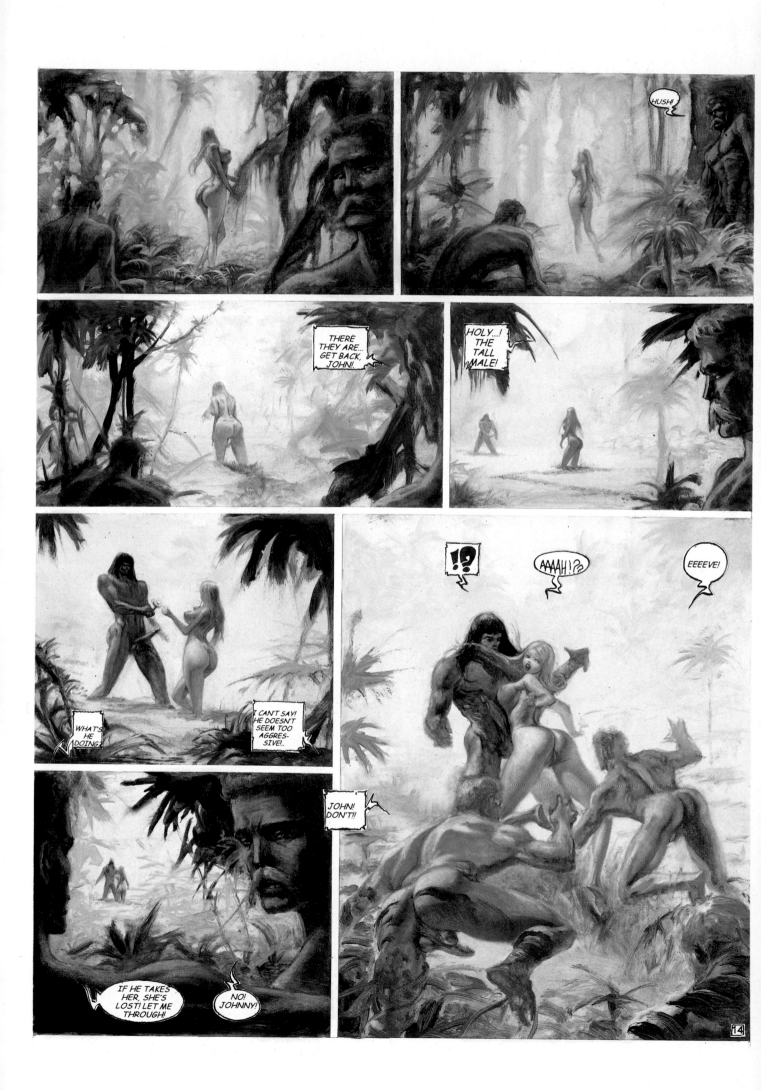

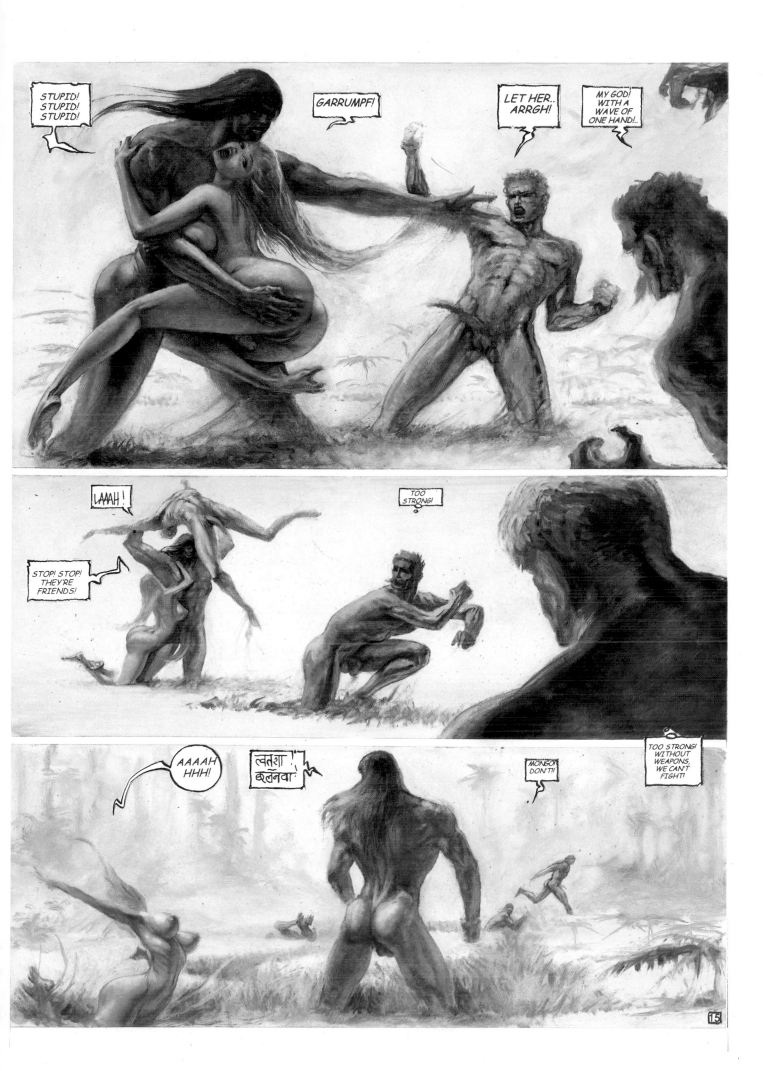

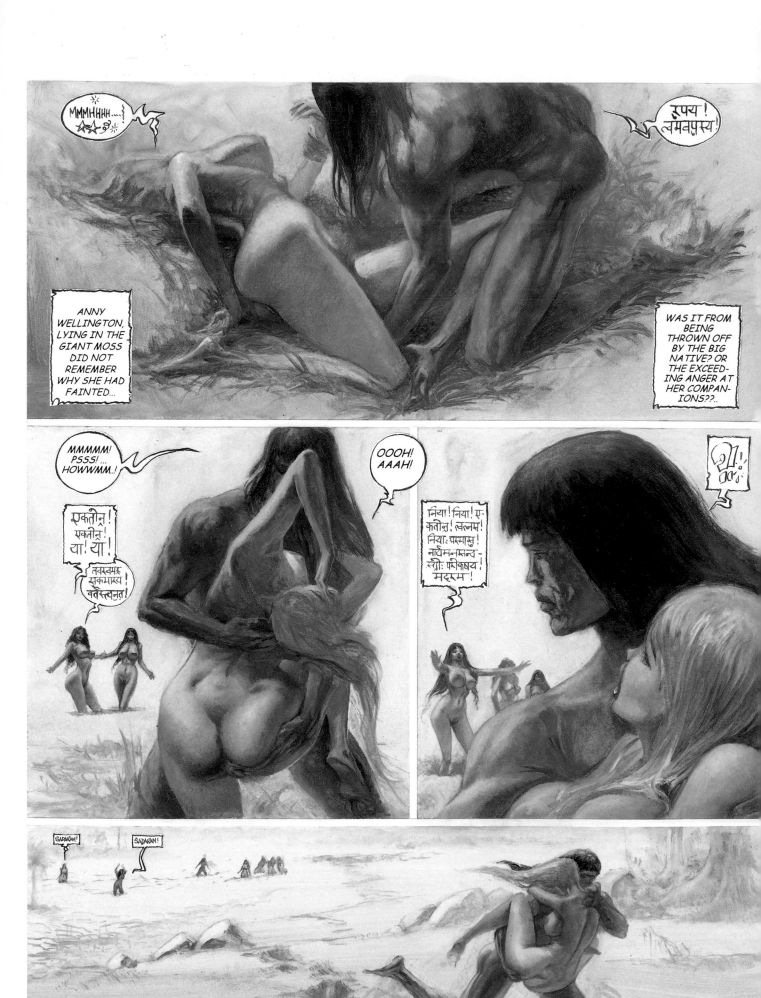

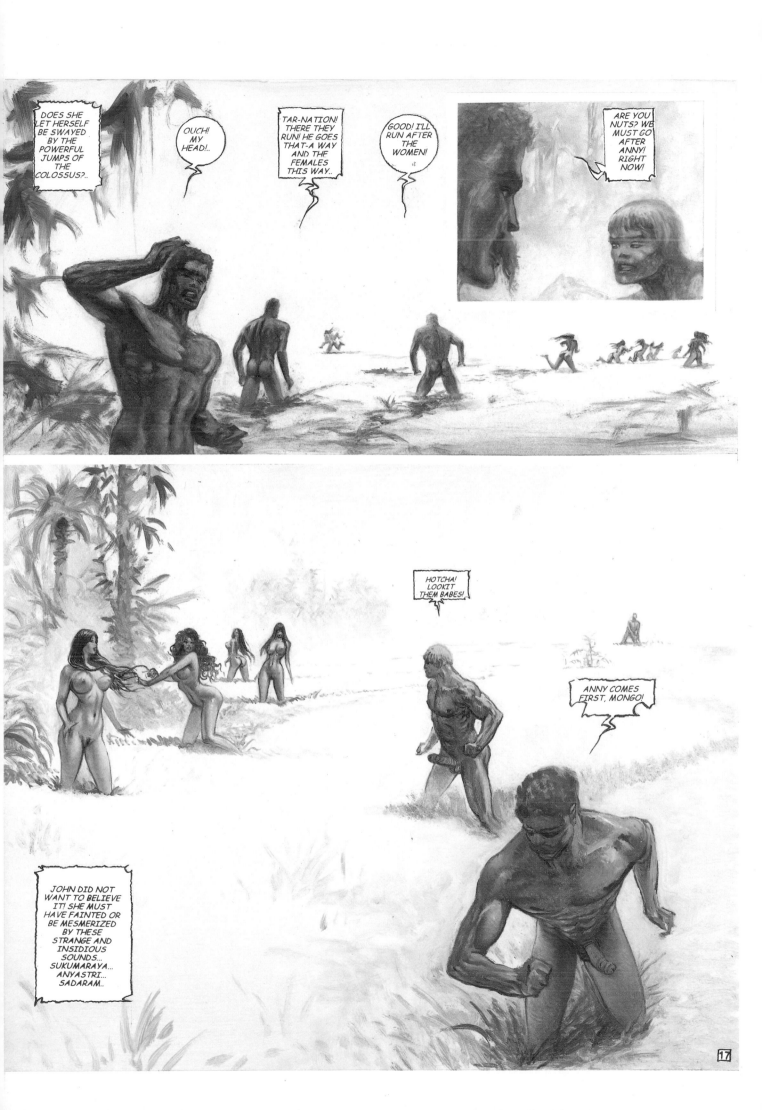

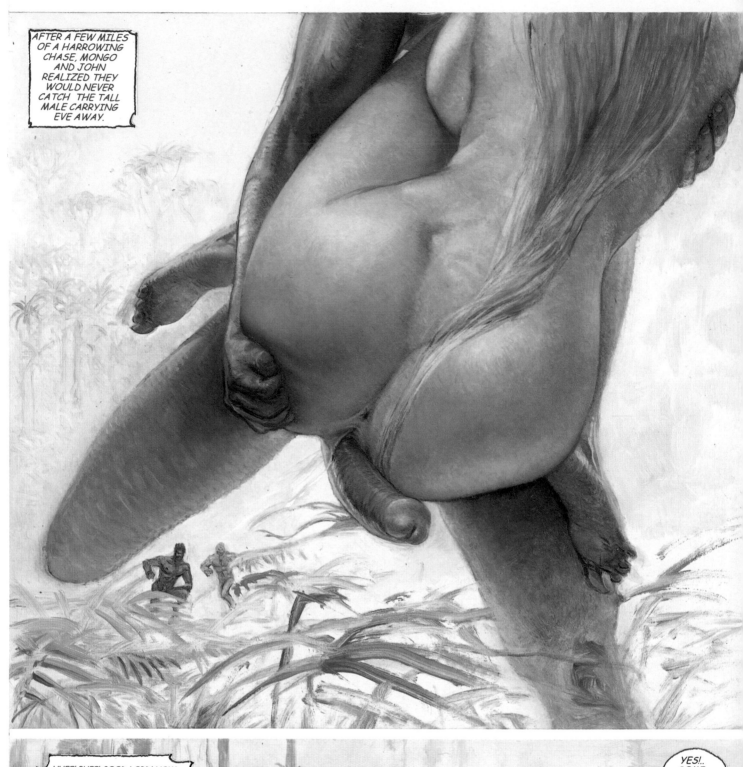

AFTER A FEW MILES OF A HARROWING CHASE, MONGO AND JOHN REALIZED THEY WOULD NEVER CATCH THE TALL MALE CARRYING EVE AWAY.

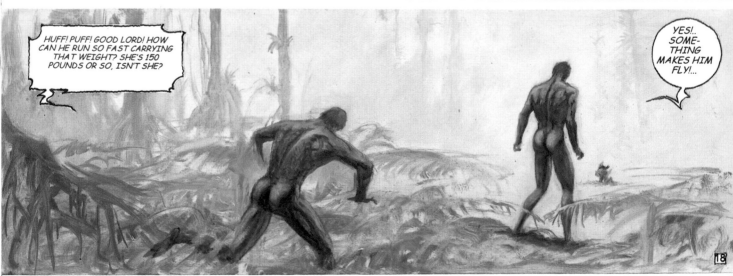

HUFF! PUFF! GOOD LORD! HOW CAN HE RUN SO FAST CARRYING THAT WEIGHT? SHE'S 150 POUNDS OR SO, ISN'T SHE?

YES!.. SOME-THING MAKES HIM FLY!...

18

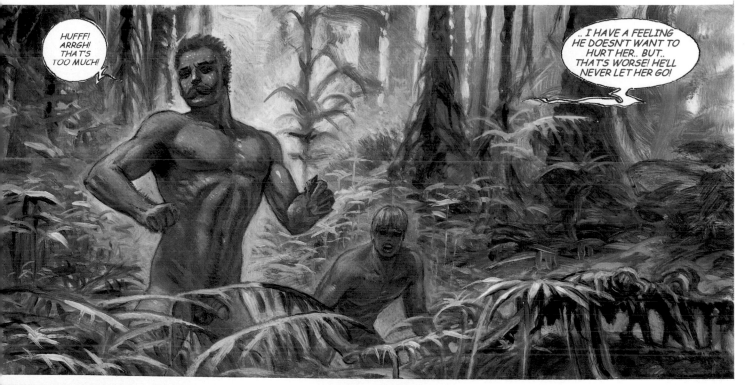

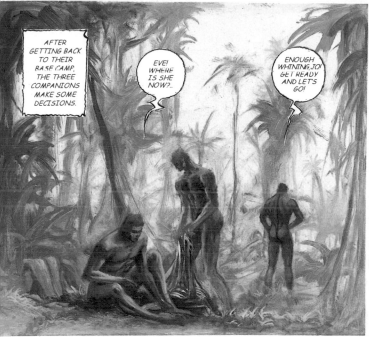

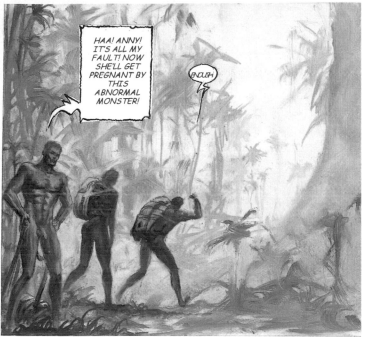

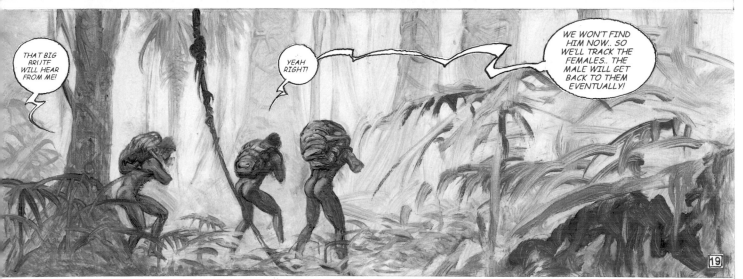

19

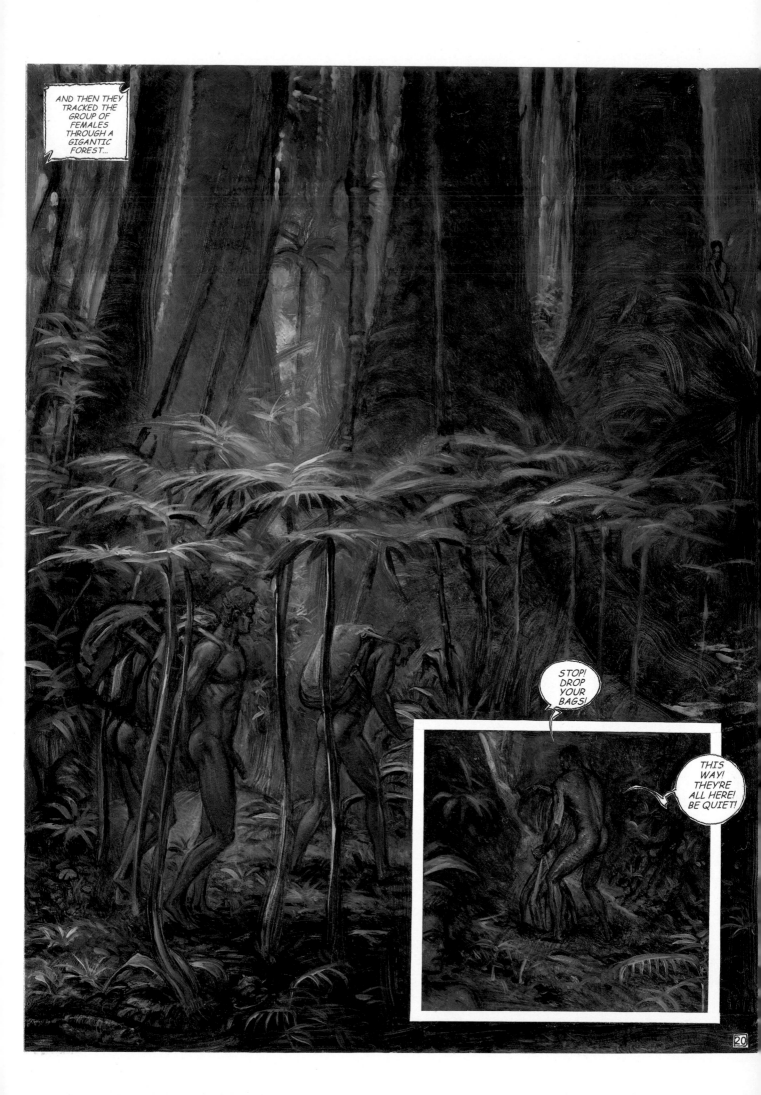

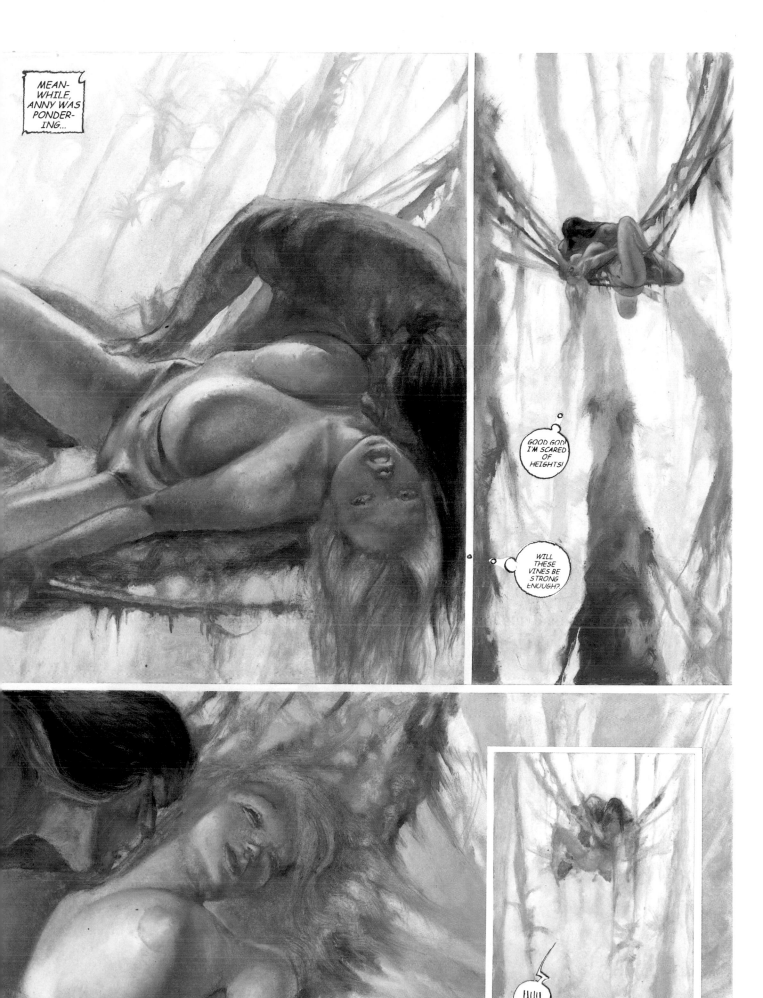

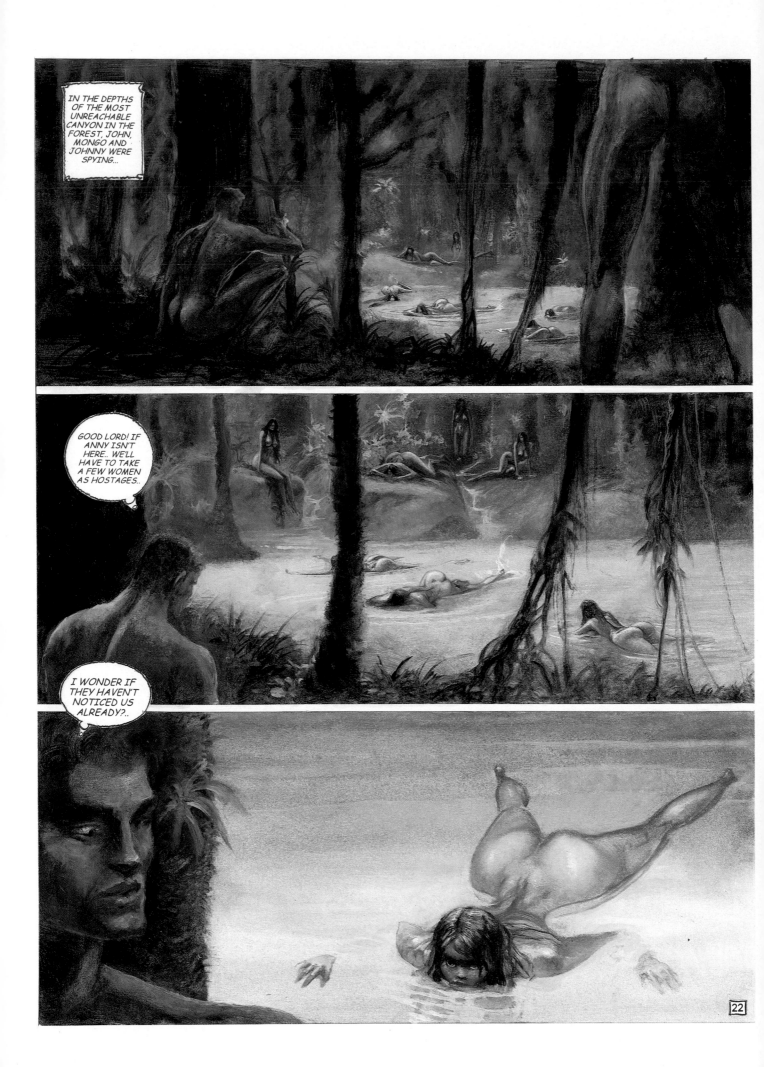

BUT...
ANNY...

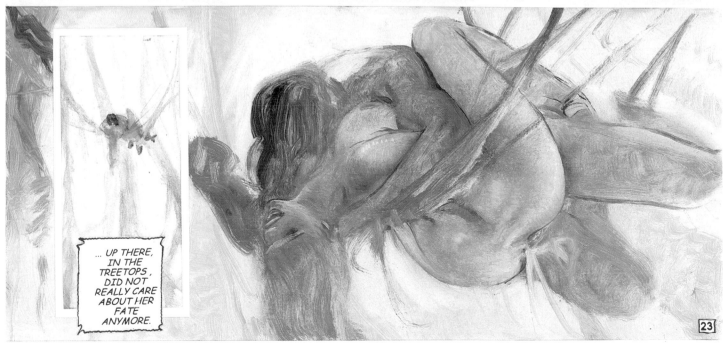

... UP THERE,
IN THE
TREETOPS,
DID NOT
REALLY CARE
ABOUT HER
FATE
ANYMORE.

23

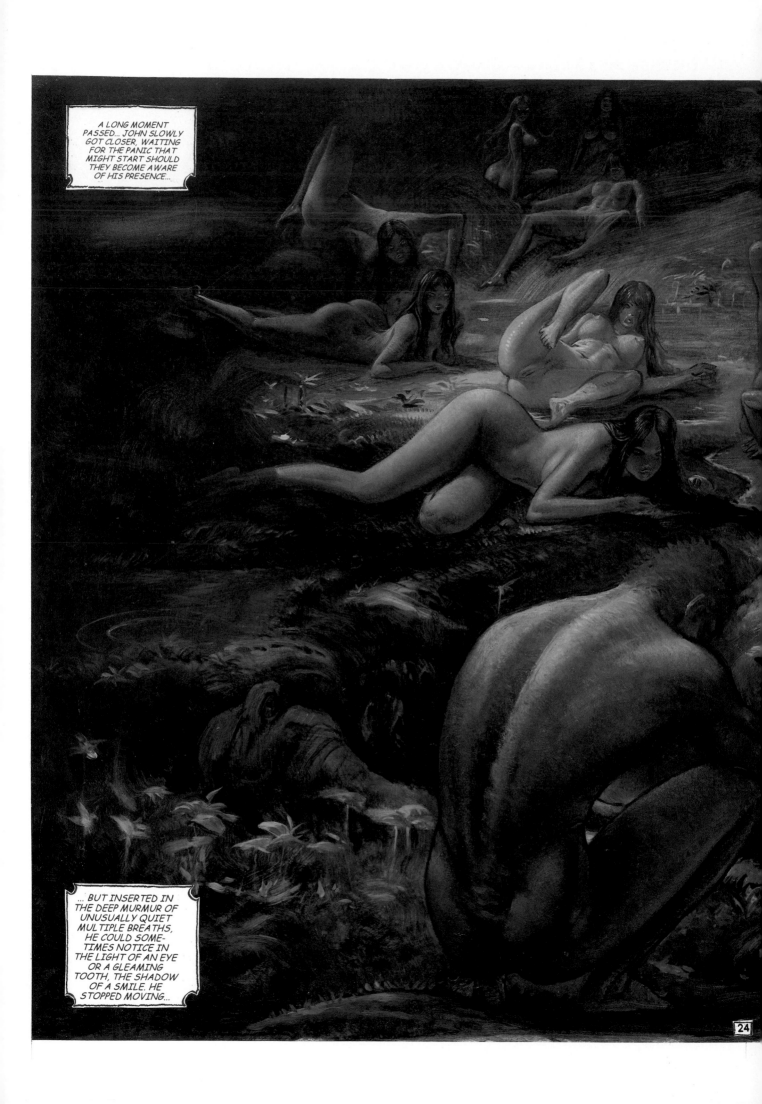

A LONG MOMENT PASSED... JOHN SLOWLY GOT CLOSER, WAITING FOR THE PANIC THAT MIGHT START SHOULD THEY BECOME AWARE OF HIS PRESENCE...

... BUT INSERTED IN THE DEEP MURMUR OF UNUSUALLY QUIET MULTIPLE BREATHS, HE COULD SOMETIMES NOTICE IN THE LIGHT OF AN EYE OR A GLEAMING TOOTH, THE SHADOW OF A SMILE. HE STOPPED MOVING...

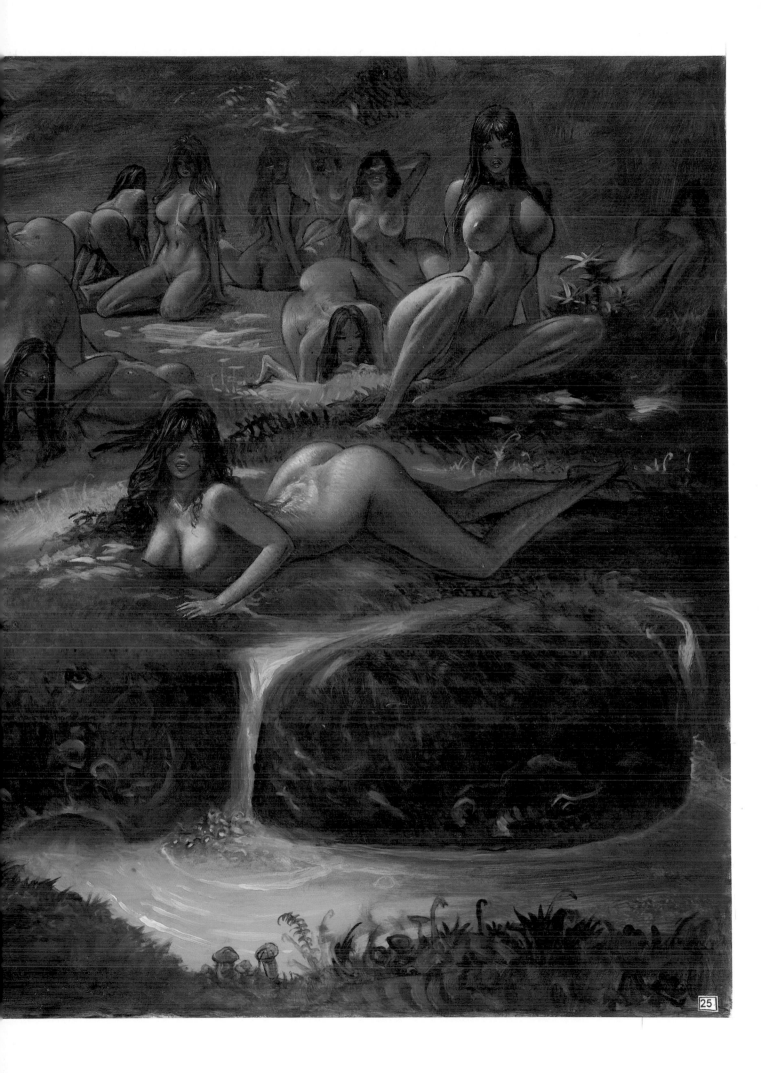

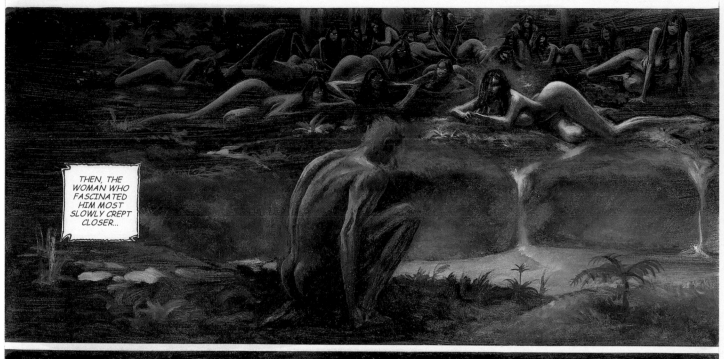

THEN, THE WOMAN WHO FASCINATED HIM MOST SLOWLY CREPT CLOSER...

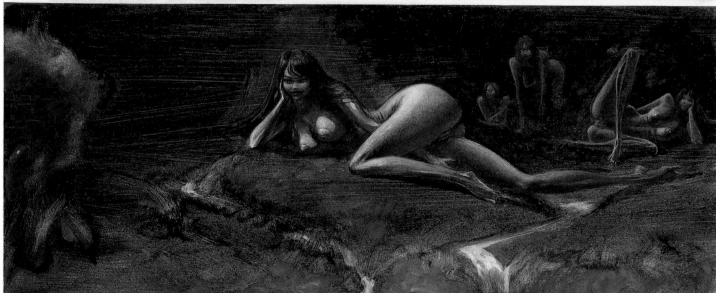

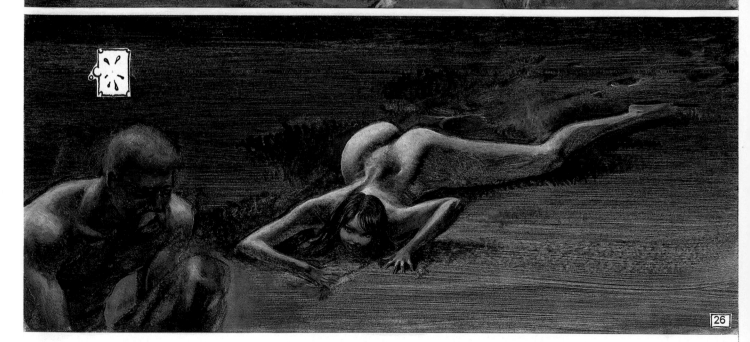

26

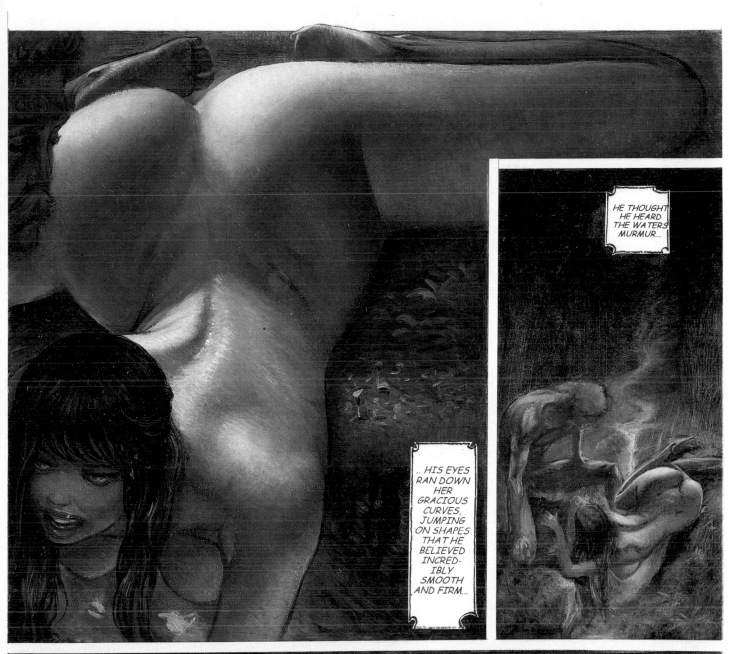

HE THOUGHT HE HEARD THE WATERS MURMUR...

.. HIS EYES RAN DOWN HER GRACIOUS CURVES, JUMPING ON SHAPES THAT HE BELIEVED INCRED- IBLY SMOOTH AND FIRM...

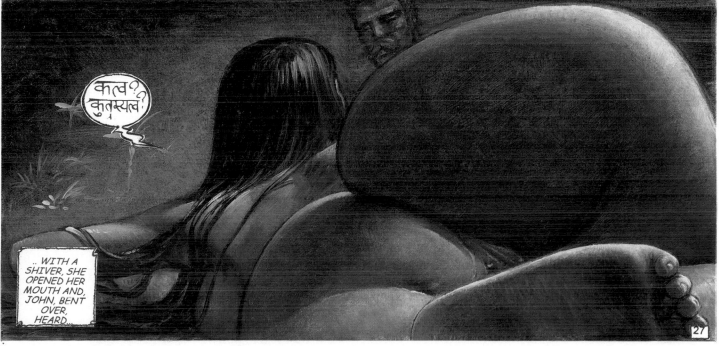

काल्व?? कुतस्याव!

.. WITH A SHIVER, SHE OPENED HER MOUTH AND, JOHN, BENT OVER, HEARD..

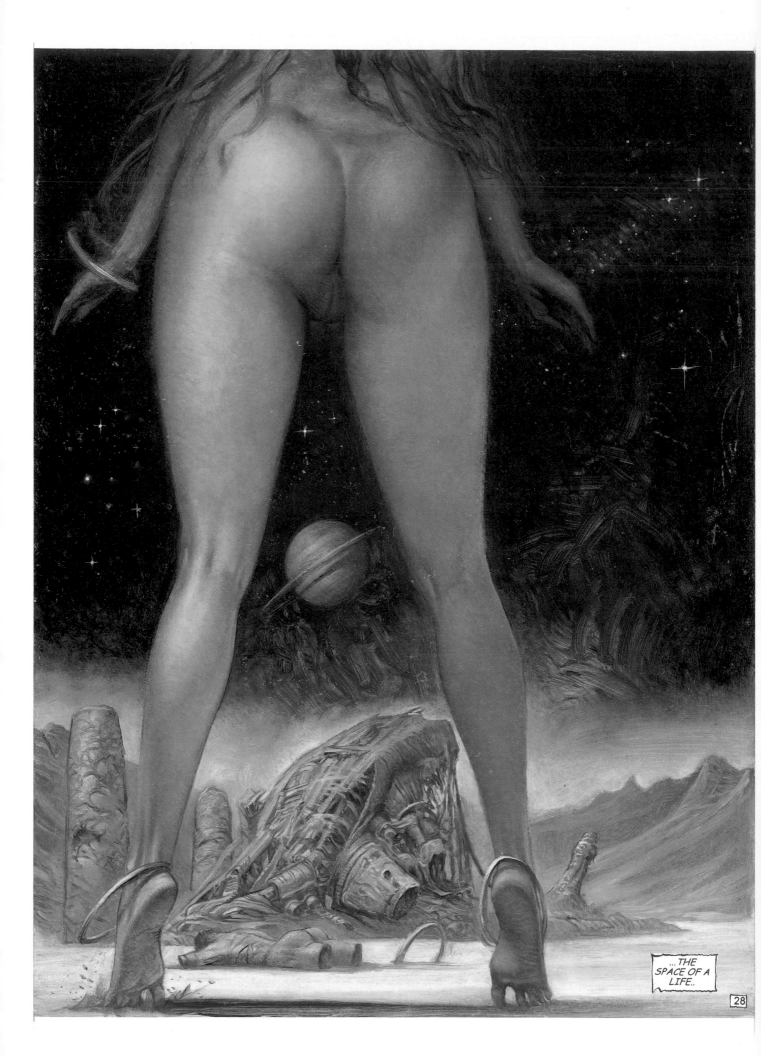

...THE
SPACE OF A
LIFE..

28

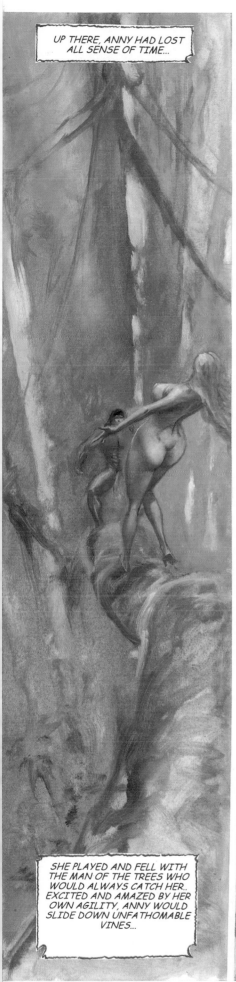

UP THERE, ANNY HAD LOST ALL SENSE OF TIME...

SHE PLAYED AND FELL WITH THE MAN OF THE TREES WHO WOULD ALWAYS CATCH HER.. EXCITED AND AMAZED BY HER OWN AGILITY, ANNY WOULD SLIDE DOWN UNFATHOMABLE VINES...

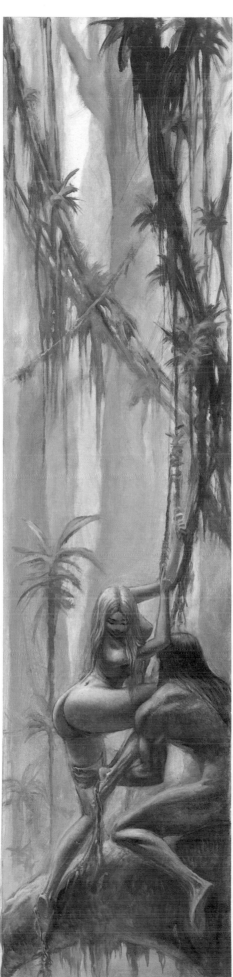

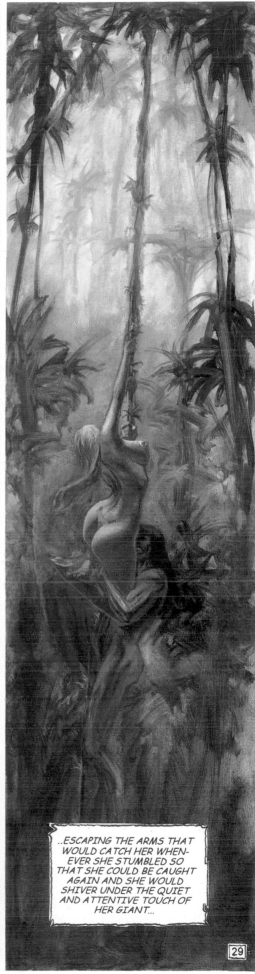

..ESCAPING THE ARMS THAT WOULD CATCH HER WHEN-EVER SHE STUMBLED SO THAT SHE COULD BE CAUGHT AGAIN AND SHE WOULD SHIVER UNDER THE QUIET AND ATTENTIVE TOUCH OF HER GIANT...

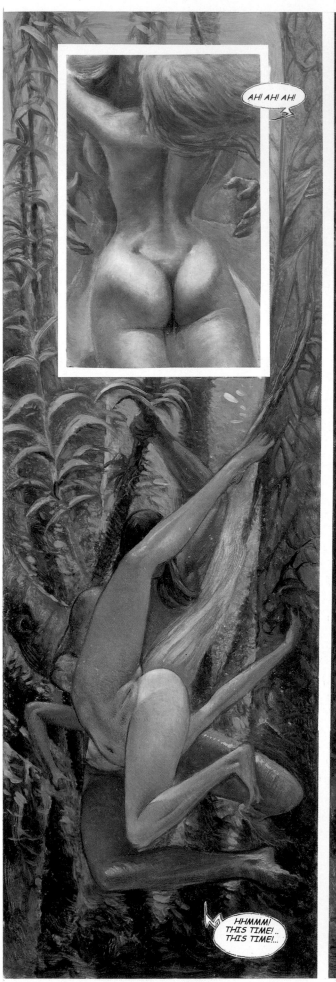

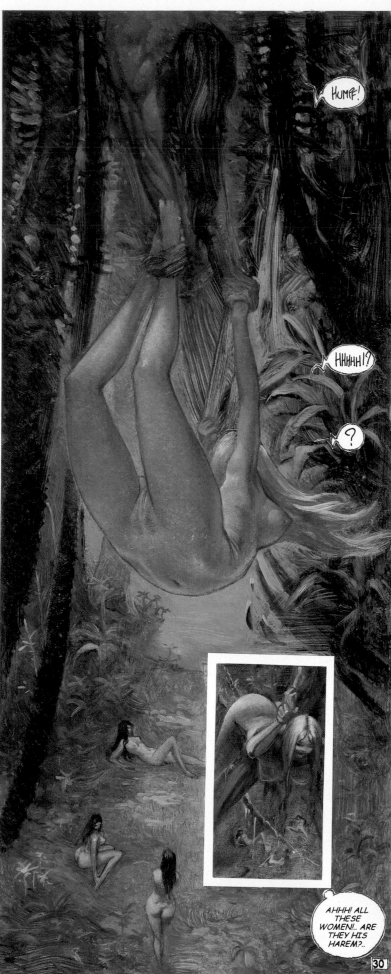

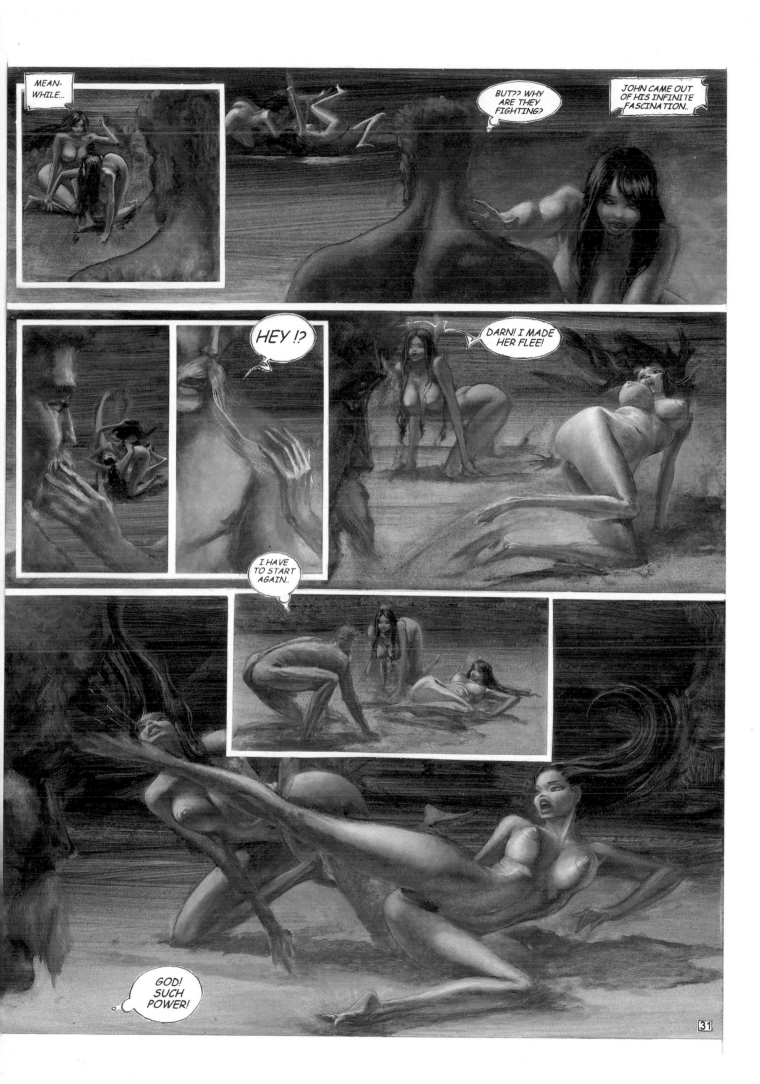

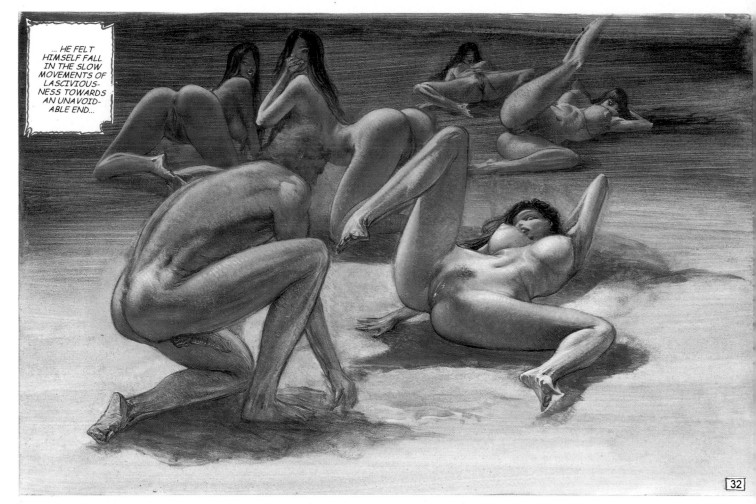

... HE FELT HIMSELF FALL IN THE SLOW MOVEMENTS OF LASCIVIOUS-NESS TOWARDS AN UNAVOID-ABLE END...

32

HOW CAN I RESIST SUCH A WILD CALL... SO ... HUMPF! ... THE GREAT MALE?.. HOLY TOOTSY!..

... HE COULD SHOW UP ANYTIME AND... NO, NO, ...GOOD LORD! IT'S IMPOSSIBLE!.. I HAVE TO RESIST! ARGGG!

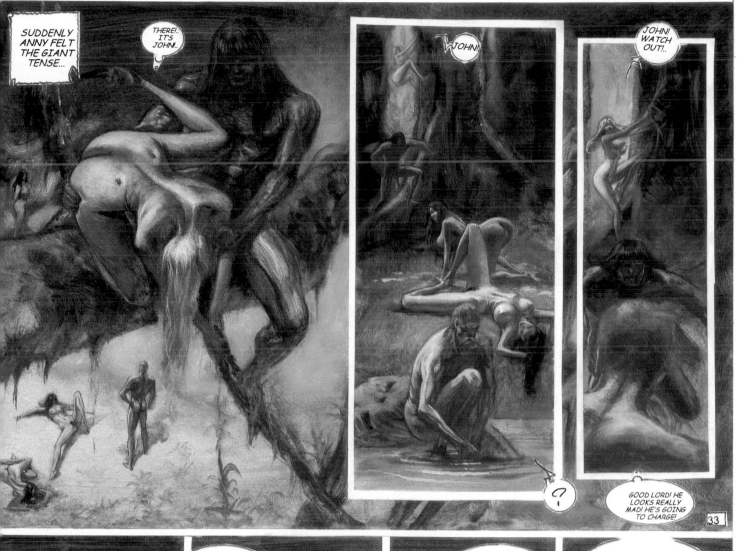

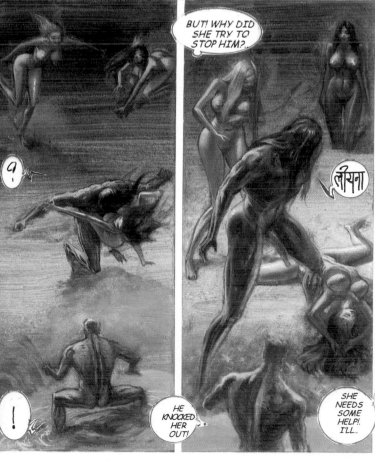

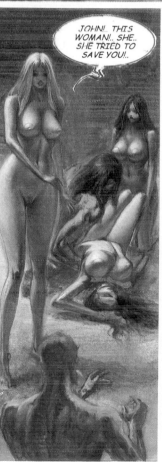

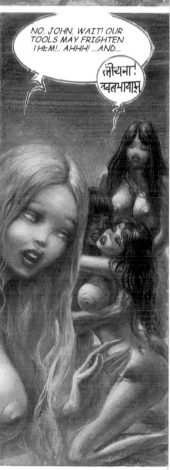

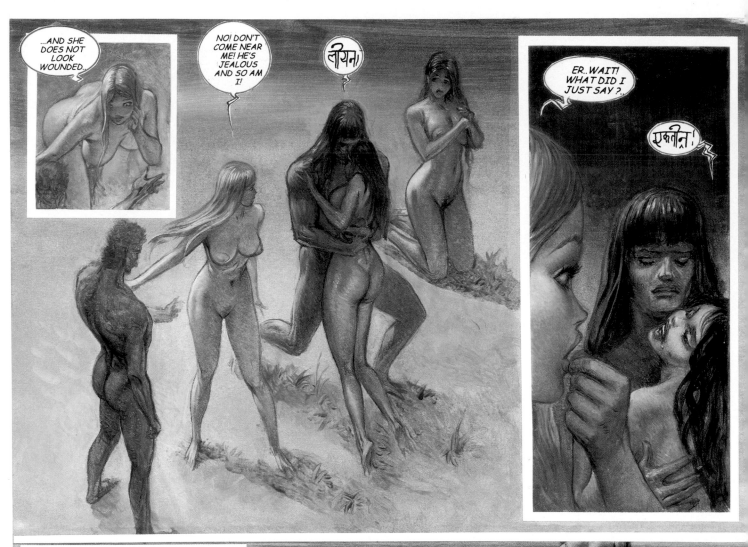

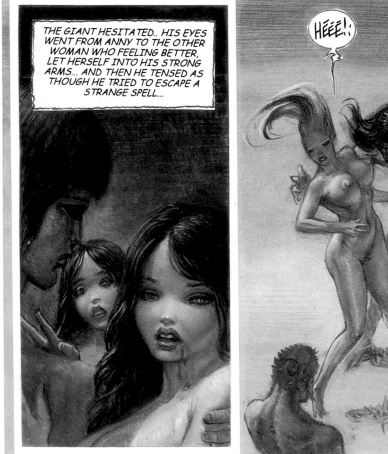

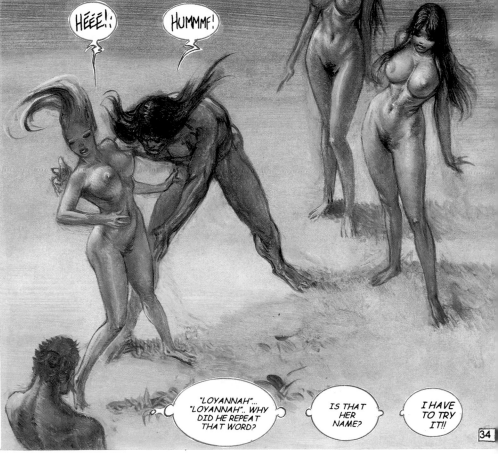

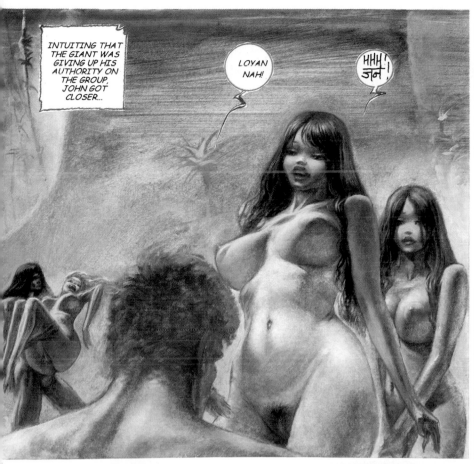

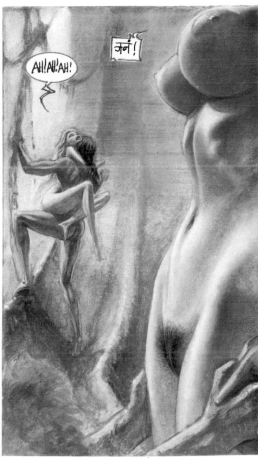

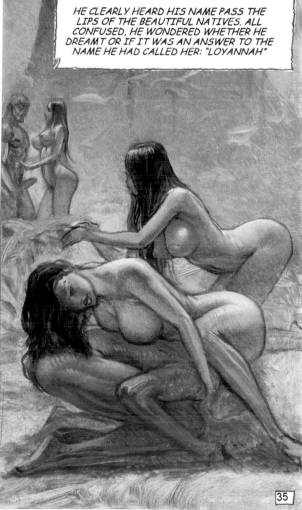

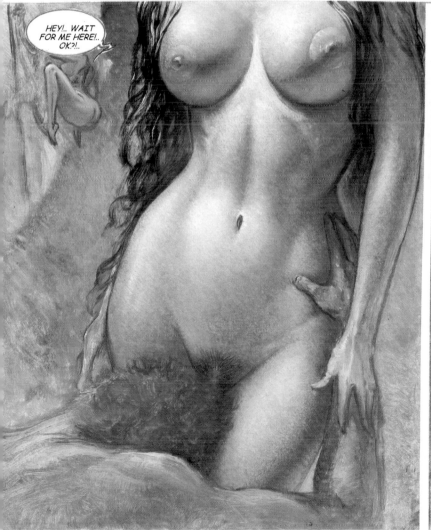

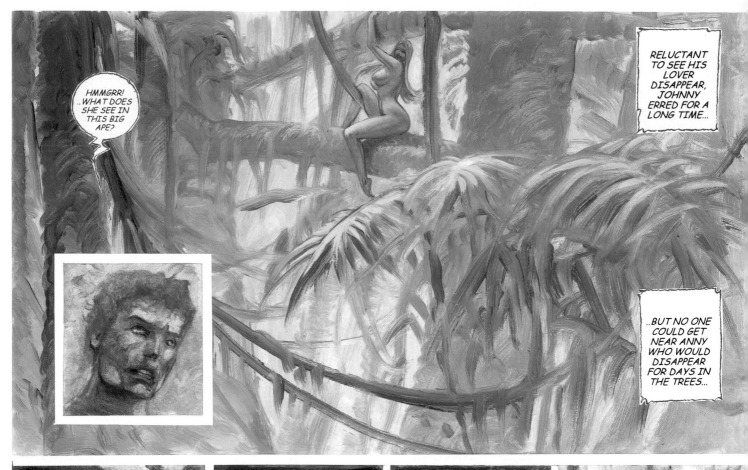

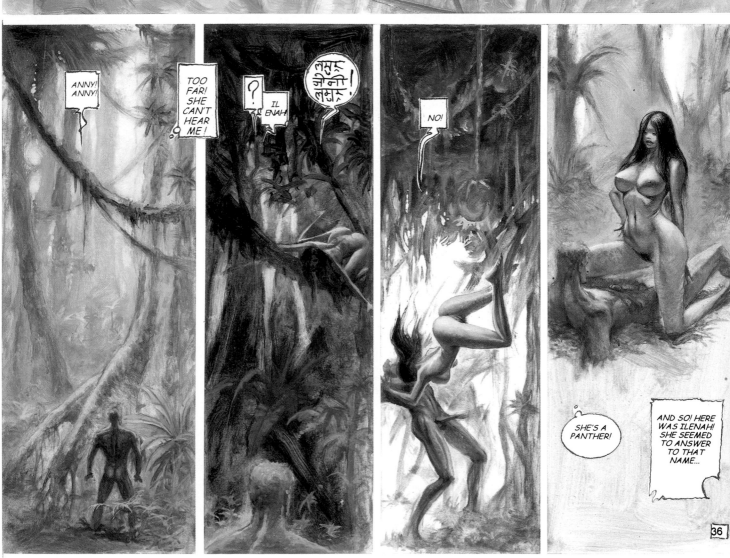

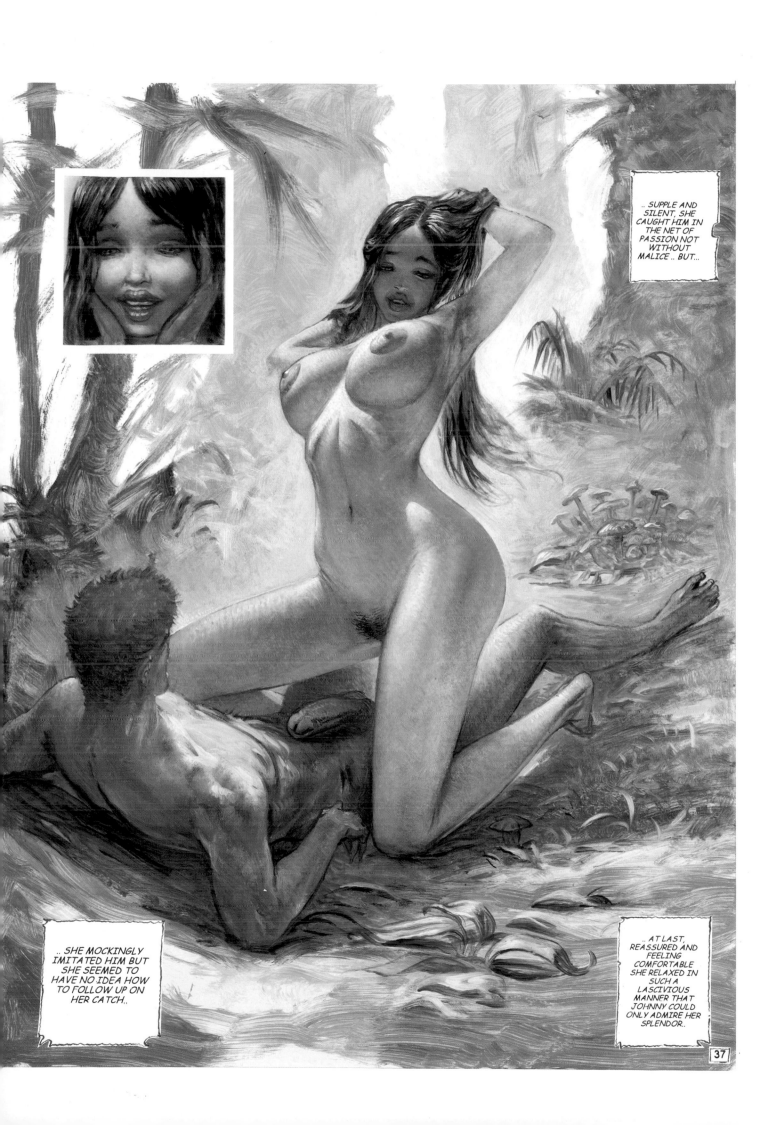

.. SUPPLE AND SILENT, SHE CAUGHT HIM IN THE NET OF PASSION NOT WITHOUT MALICE .. BUT...

.. SHE MOCKINGLY IMITATED HIM BUT SHE SEEMED TO HAVE NO IDEA HOW TO FOLLOW UP ON HER CATCH..

.. AT LAST, REASSURED AND FEELING COMFORTABLE SHE RELAXED IN SUCH A LASCIVIOUS MANNER THAT JOHNNY COULD ONLY ADMIRE HER SPLENDOR..

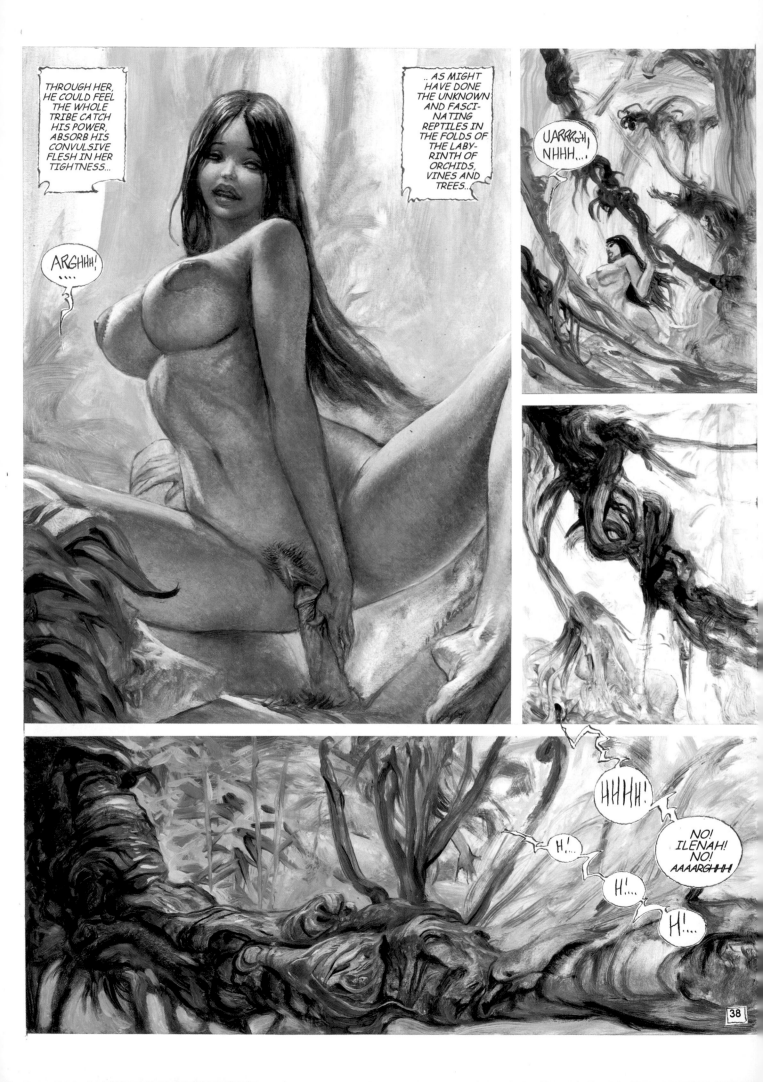

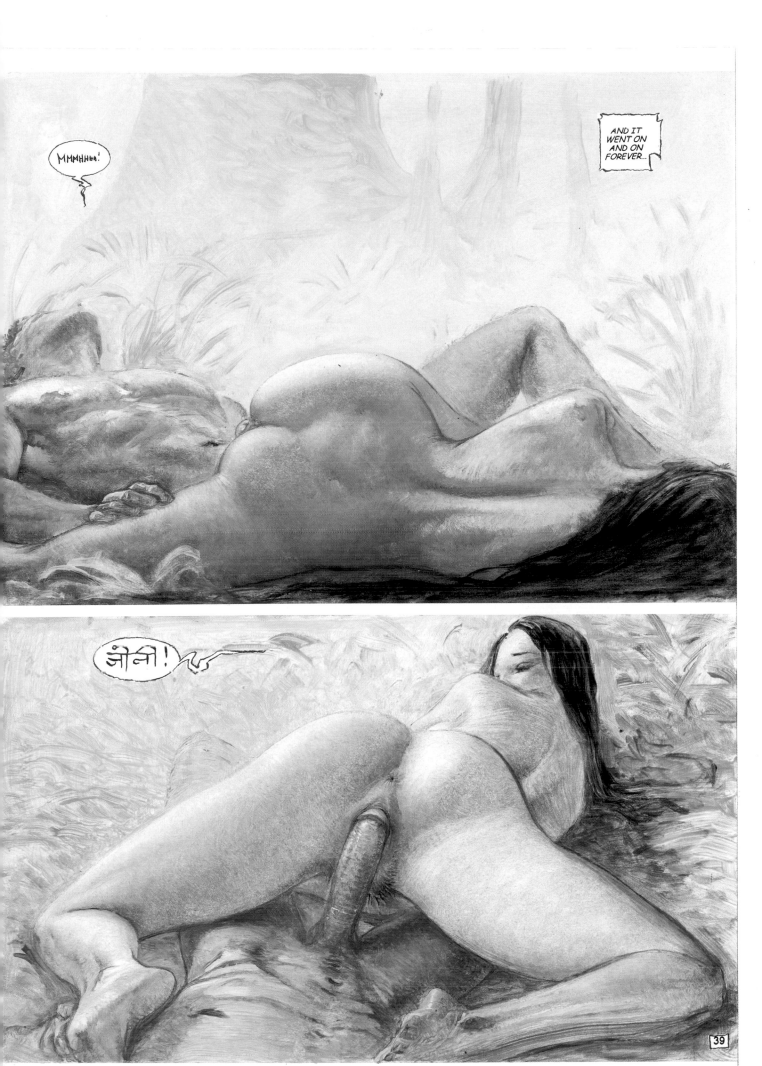

YET..

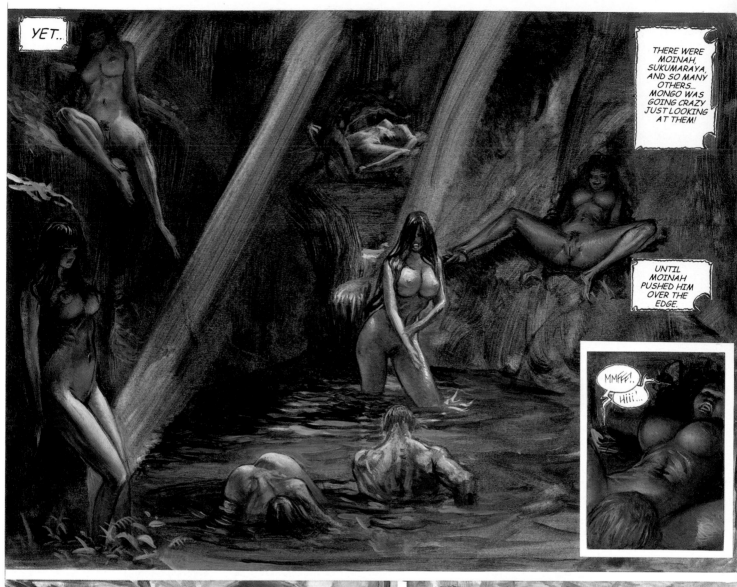

THERE WERE MOINAH, SUKUMARAYA, AND SO MANY OTHERS... MONGO WAS GOING CRAZY JUST LOOKING AT THEM!

UNTIL MOINAH PUSHED HIM OVER THE EDGE.

MMFFF!..

HIII!..

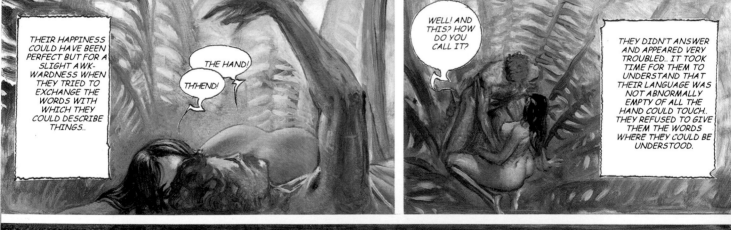

THEIR HAPPINESS COULD HAVE BEEN PERFECT BUT FOR A SLIGHT AWK-WARDNESS WHEN THEY TRIED TO EXCHANGE THE WORDS WITH WHICH THEY COULD DESCRIBE THINGS..

THE HAND!

TH'HEND!

WELL! AND THIS? HOW DO YOU CALL IT?

THEY DIDN'T ANSWER AND APPEARED VERY TROUBLED.. IT TOOK TIME FOR THEM TO UNDERSTAND THAT THEIR LANGUAGE WAS NOT ABNORMALLY EMPTY OF ALL THE HAND COULD TOUCH.. THEY REFUSED TO GIVE THEM THE WORDS WHERE THEY COULD BE UNDERSTOOD.

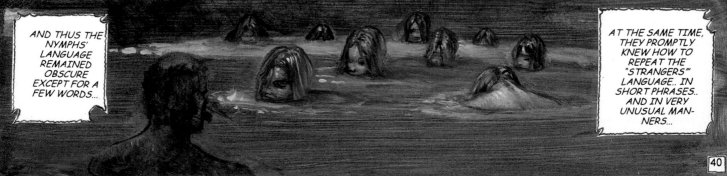

AND THUS THE NYMPHS' LANGUAGE REMAINED OBSCURE EXCEPT FOR A FEW WORDS...

AT THE SAME TIME, THEY PROMPTLY KNEW HOW TO REPEAT THE "STRANGERS" LANGUAGE.. IN SHORT PHRASES.. AND IN VERY UNUSUAL MAN-NERS...

40

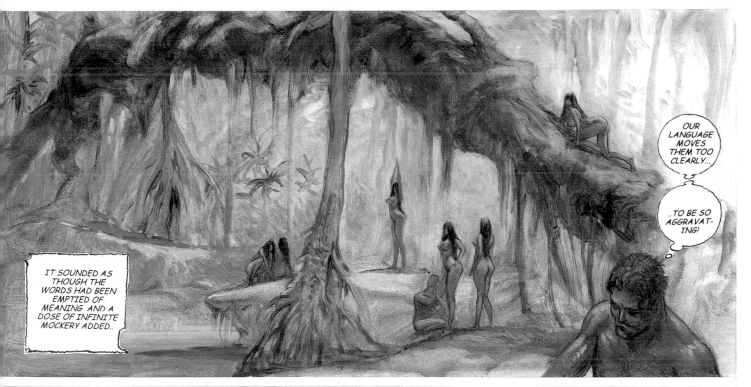

OUR LANGUAGE MOVES THEM TOO CLEARLY...

..TO BE SO AGGRAVAT-ING!

IT SOUNDED AS THOUGH THE WORDS HAD BEEN EMPTIED OF MEANING AND A DOSE OF INFINITE MOCKERY ADDED..

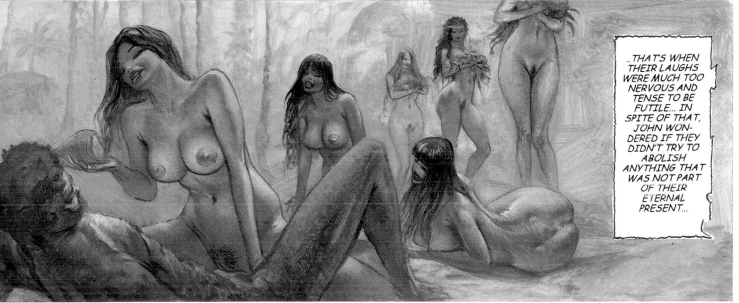

..THAT'S WHEN THEIR LAUGHS WERE MUCH TOO NERVOUS AND TENSE TO BE FUTILE... IN SPITE OF THAT, JOHN WONDERED IF THEY DIDN'T TRY TO ABOLISH ANYTHING THAT WAS NOT PART OF THEIR ETERNAL PRESENT...

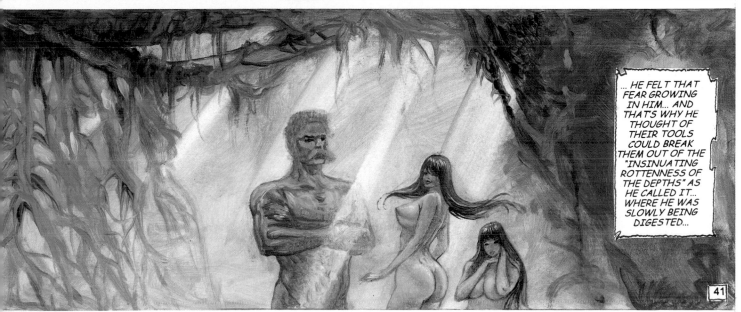

... HE FELT THAT FEAR GROWING IN HIM... AND THAT'S WHY HE THOUGHT OF THEIR TOOLS COULD BREAK THEM OUT OF THE "INSINUATING ROTTENNESS OF THE DEPTHS" AS HE CALLED IT... WHERE HE WAS SLOWLY BEING DIGESTED...

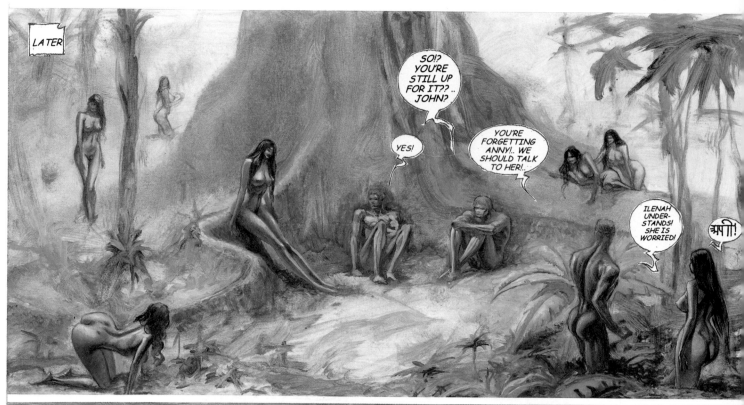

LATER

SO!? YOU'RE STILL UP FOR IT?? .. JOHN?

YES!

YOU'RE FORGETTING ANNY!.. WE SHOULD TALK TO HER!..

ILENAH UNDERSTANDS! SHE IS WORRIED!

अप्पी!

LEAVE ANNY ALONE, JOHNNY!.. ETHNOLOGY! DOING FIELD WORK TO FORGET WE CAN NEVER GO HOME!.. WE ARE HERE!..

WITH THEM! .. FOREVER..

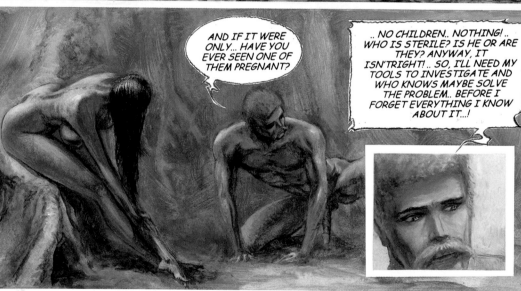

AND IF IT WERE ONLY... HAVE YOU EVER SEEN ONE OF THEM PREGNANT?

.. NO CHILDREN.. NOTHING! .. WHO IS STERILE? IS HE OR ARE THEY? ANYWAY, IT ISN'T RIGHT! .. SO, I'LL NEED MY TOOLS TO INVESTIGATE AND WHO KNOWS MAYBE SOLVE THE PROBLEM.. BEFORE I FORGET EVERYTHING I KNOW ABOUT IT...!

AND SO THE GIANT IS STERILE! ANNY IS LUCKY!

OK! LETS GO!

42

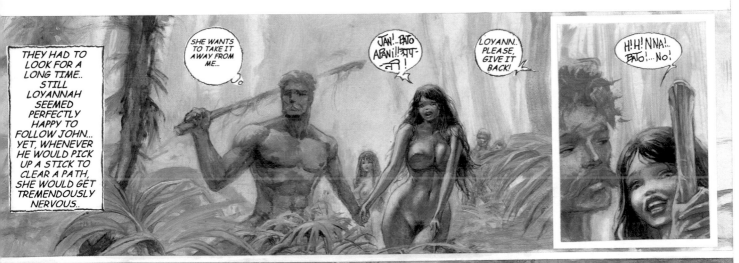

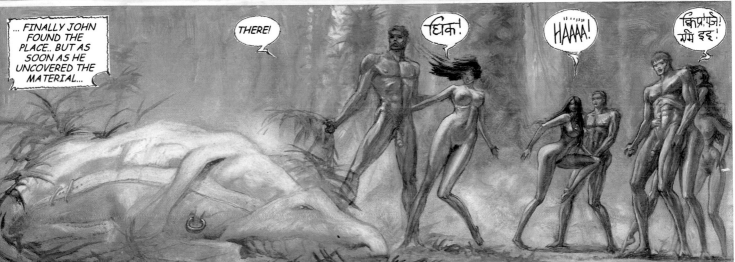

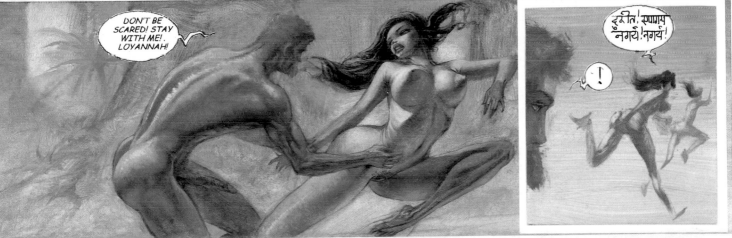

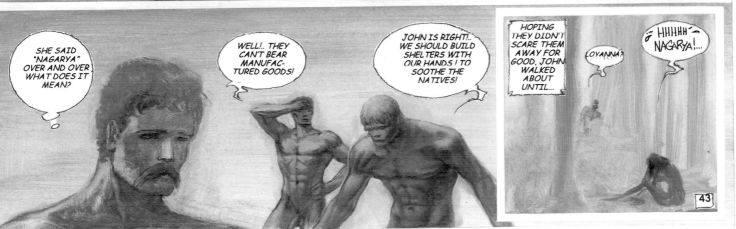

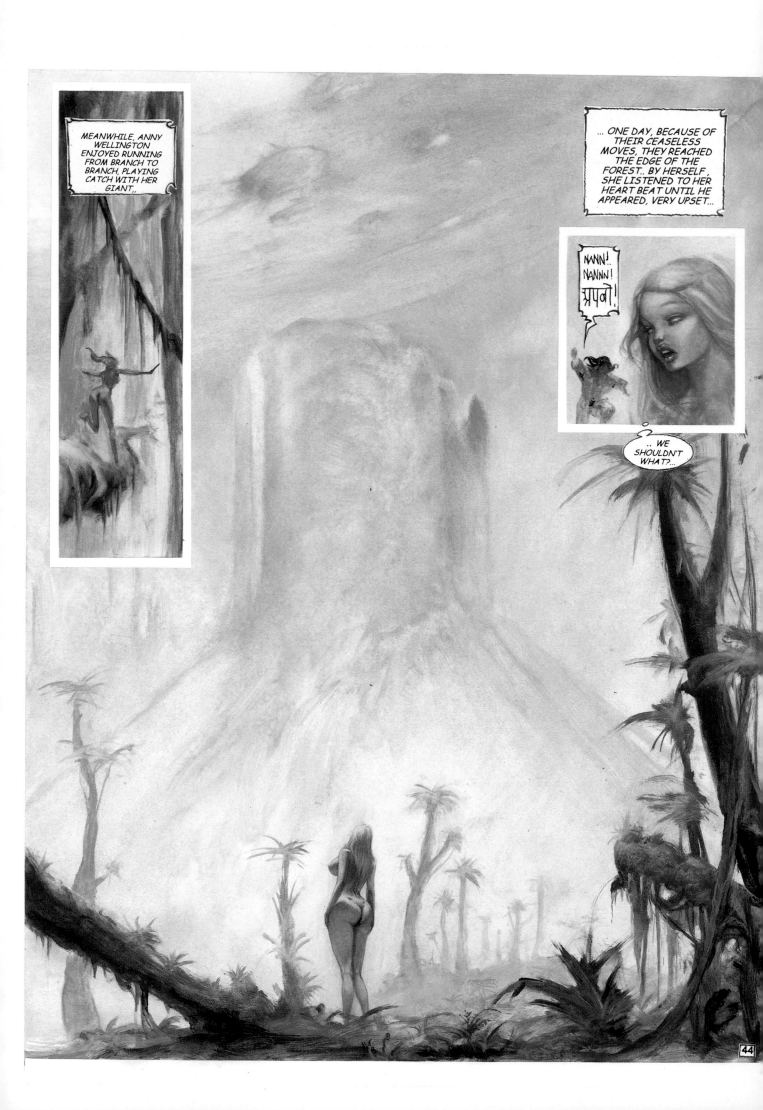

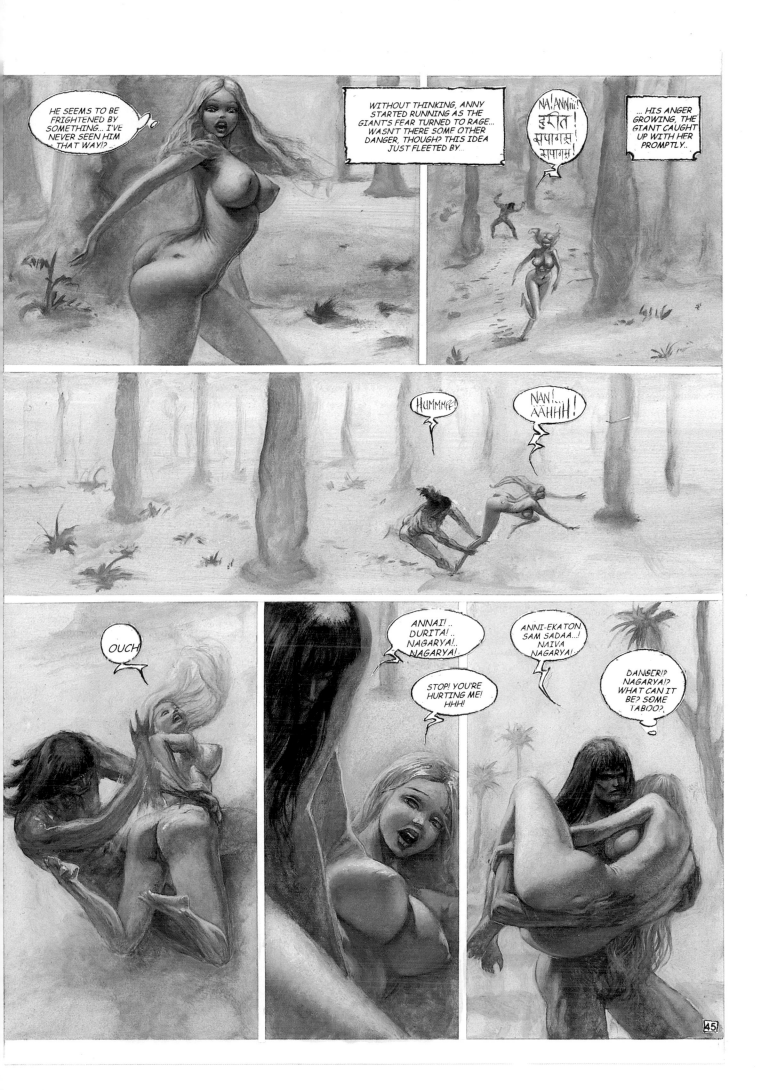

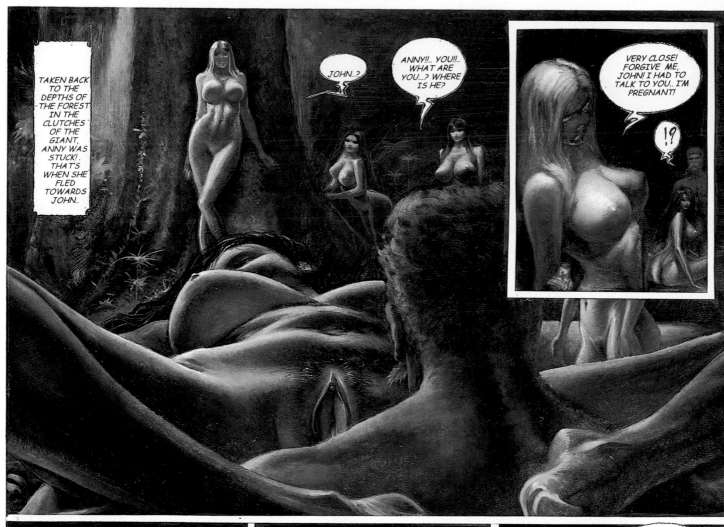

TAKEN BACK TO THE DEPTHS OF THE FOREST IN THE CLUTCHES OF THE GIANT, ANNY WAS STUCK!. THAT'S WHEN SHE FLED TOWARDS JOHN..

JOHN..?

ANNY!!.. YOU!!.. WHAT ARE YOU...? WHERE IS HE?

VERY CLOSE! FORGIVE ME, JOHN! I HAD TO TALK TO YOU.. I'M PREGNANT!

!?

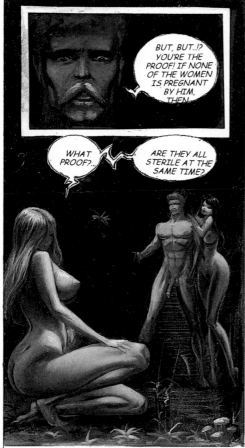

BUT, BUT..!? YOU'RE THE PROOF! IF NONE OF THE WOMEN IS PREGNANT BY HIM, THEN..

WHAT PROOF?..

ARE THEY ALL STERILE AT THE SAME TIME?

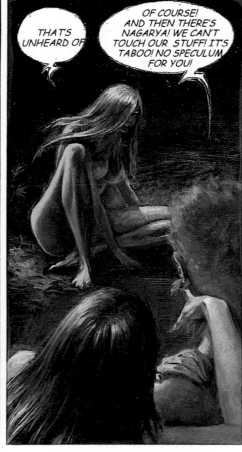

THAT'S UNHEARD OF..

OF COURSE! AND THEN THERE'S NAGARYA! WE CAN'T TOUCH OUR STUFF! IT'S TABOO! NO SPECULUM FOR YOU!

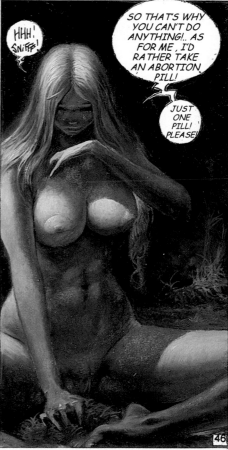

HHH! SNIFFF!

SO THAT'S WHY YOU CAN'T DO ANYTHING!.. AS FOR ME, I'D RATHER TAKE AN ABORTION PILL!

JUST ONE PILL! PLEASE!

46

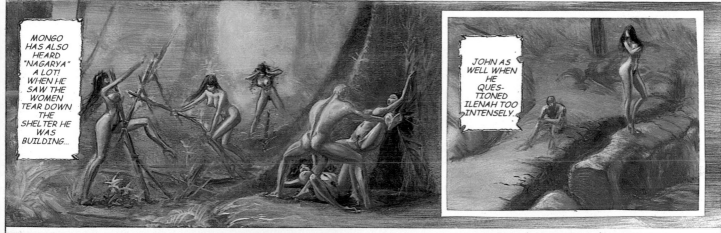

MONGO HAS ALSO HEARD "NAGARYA" A LOT! WHEN HE SAW THE WOMEN TEAR DOWN THE SHELTER HE WAS BUILDING...

JOHN AS WELL WHEN HE QUESTIONED ILENAH TOO INTENSELY..

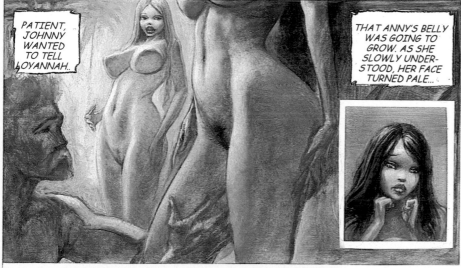

PATIENT, JOHNNY WANTED TO TELL LOYANNAH..

THAT ANNY'S BELLY WAS GOING TO GROW. AS SHE SLOWLY UNDERSTOOD, HER FACE TURNED PALE...

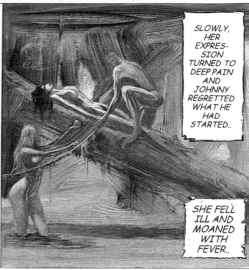

SLOWLY, HER EXPRESSION TURNED TO DEEP PAIN AND JOHNNY REGRETTED WHAT HE HAD STARTED..

SHE FELL ILL AND MOANED WITH FEVER..

OH MY QUEEN!.. YOU ARE DYING.. I NEED MY TOOLS!

THE QUEEN WAS NOT STRONG ENOUGH TO FORBID IT...

AND AS HE WAS ALLOWED TO USE HIS TOOLS, HE DISCOVERED WHAT HE THOUGHT SHE HAD IN HER..

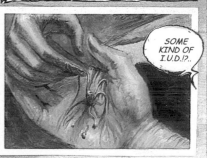

SOME KIND OF I.U.D.!?..

47

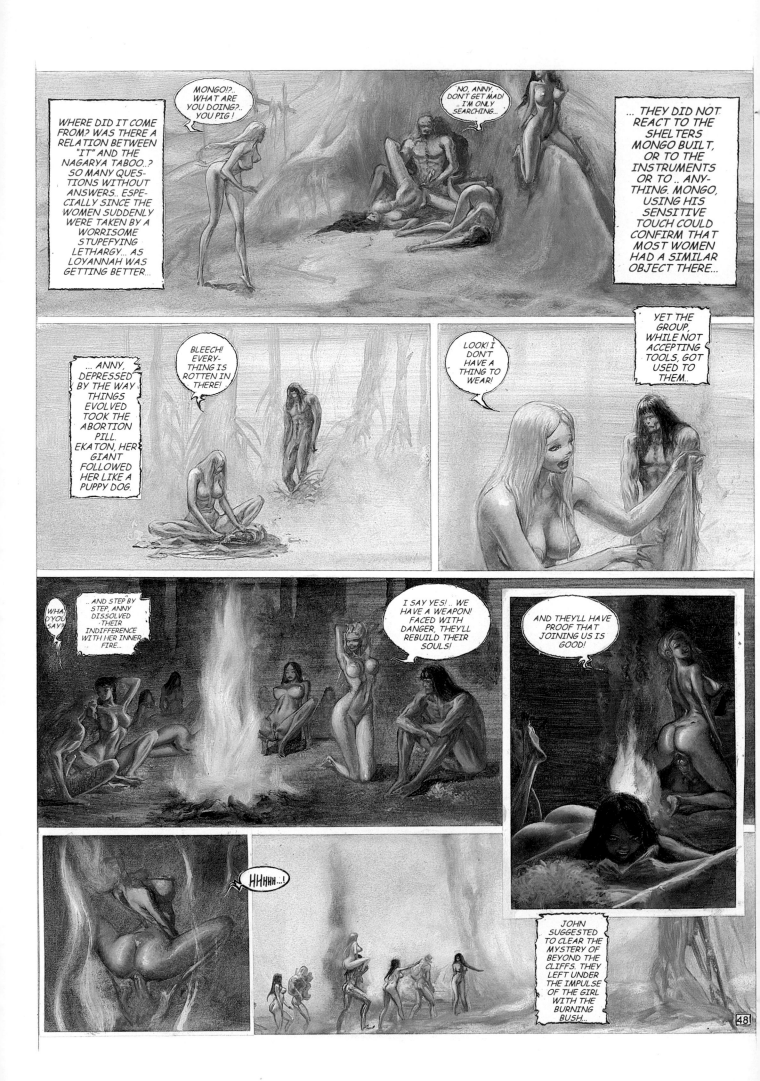

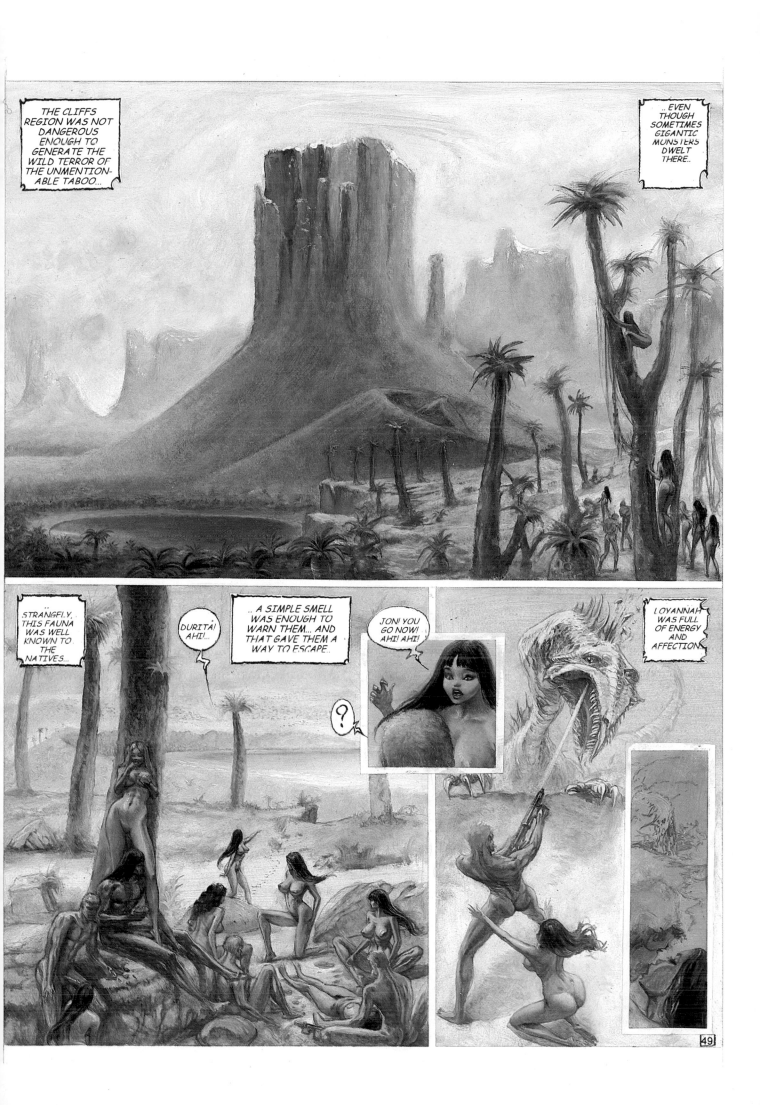

AS DAYS WENT BY, THE NATIVES SLOWLY RECOVERED THEIR POWERS..

MONGO MADE SOME SPEARS BUT PROMPTLY DISCOVERED THAT EKATON WAS MUCH BETTER AT IT THAN HE WAS... YET ANOTHER MYSTERY TO ADD TO LOYANNAH'S SMILE..

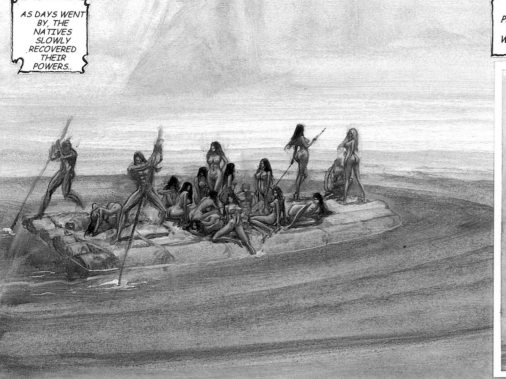

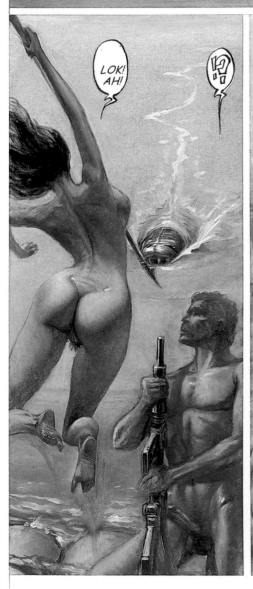

LOK! AH!

!?

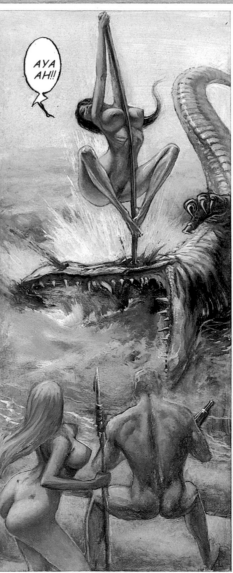

AYA AH!!

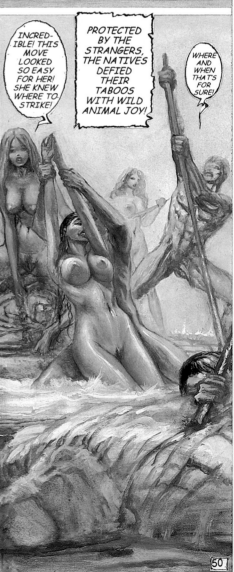

INCREDIBLE! THIS MOVE LOOKED SO EASY FOR HER! SHE KNEW WHERE TO STRIKE!

PROTECTED BY THE STRANGERS, THE NATIVES DEFIED THEIR TABOOS WITH WILD ANIMAL JOY!

WHERE AND WHEN THAT'S FOR SURE!

50

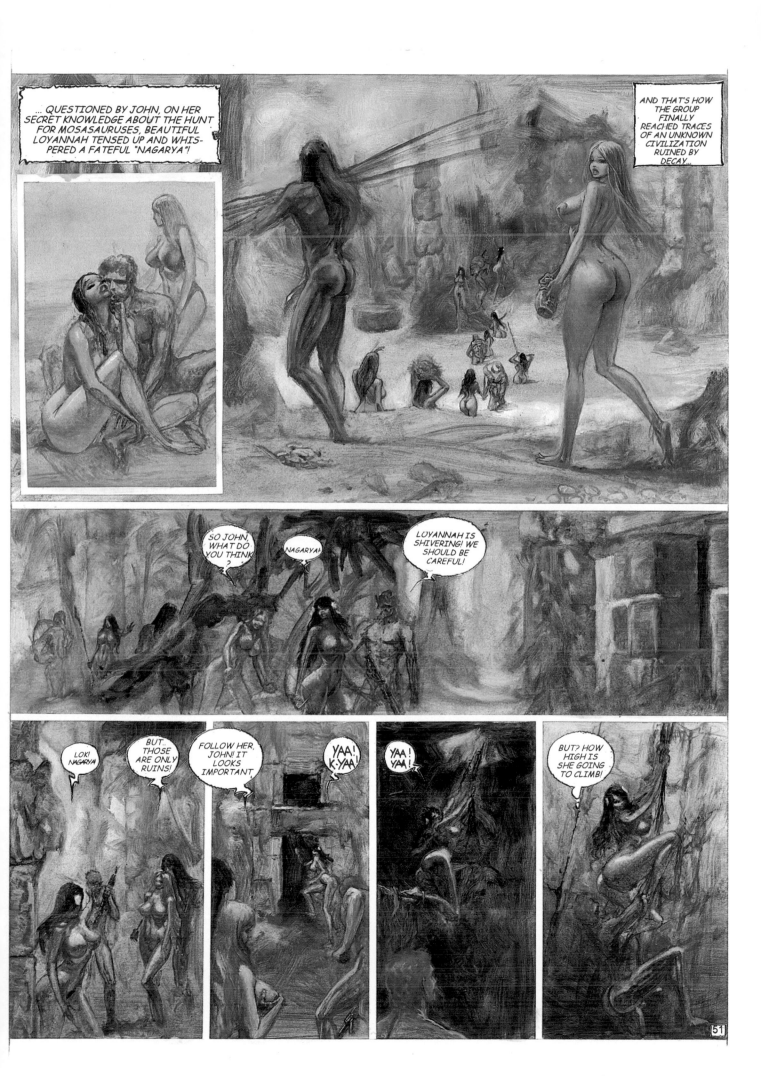

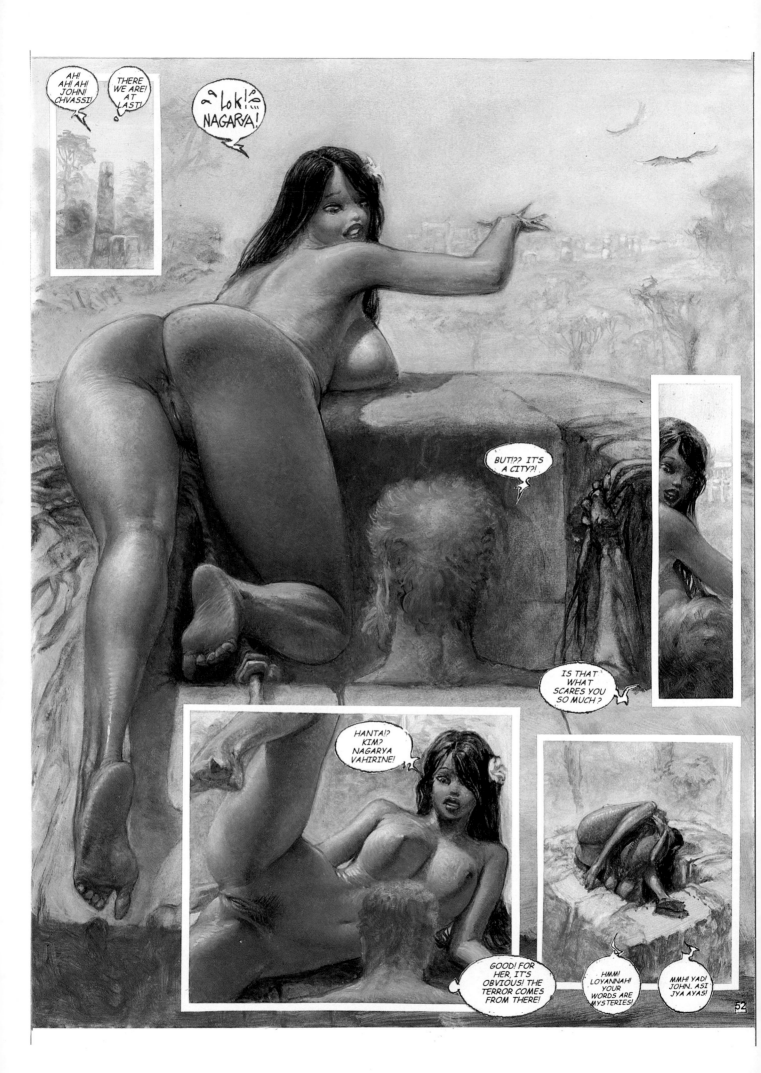

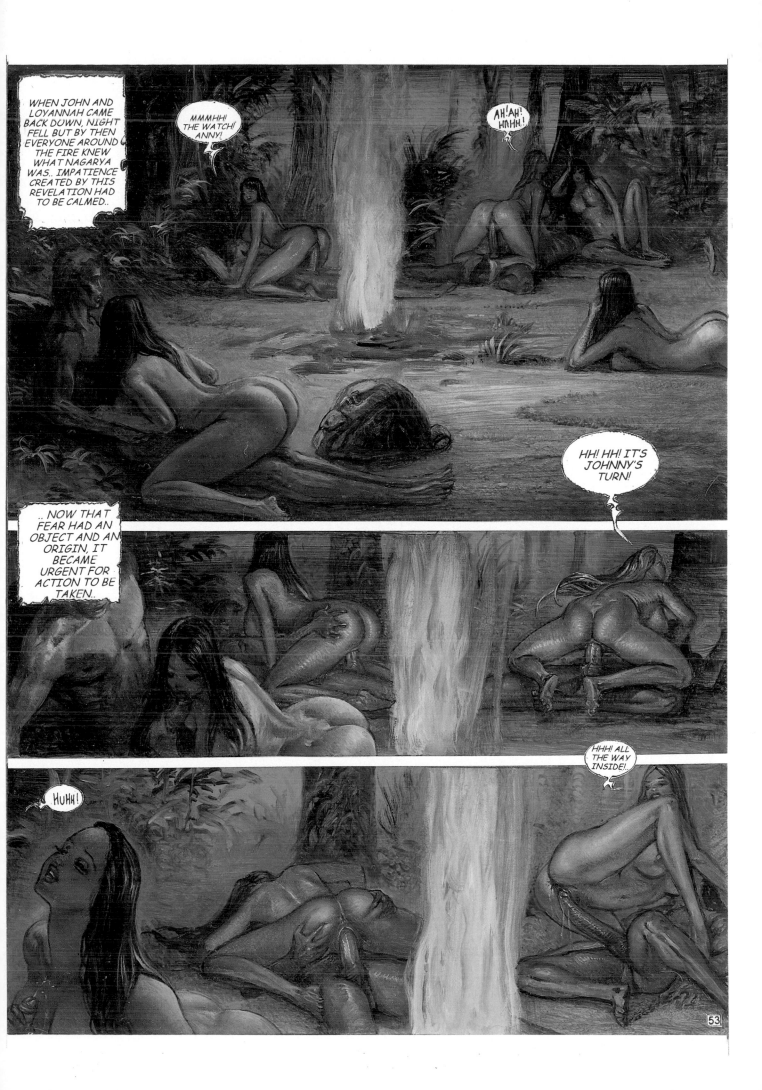

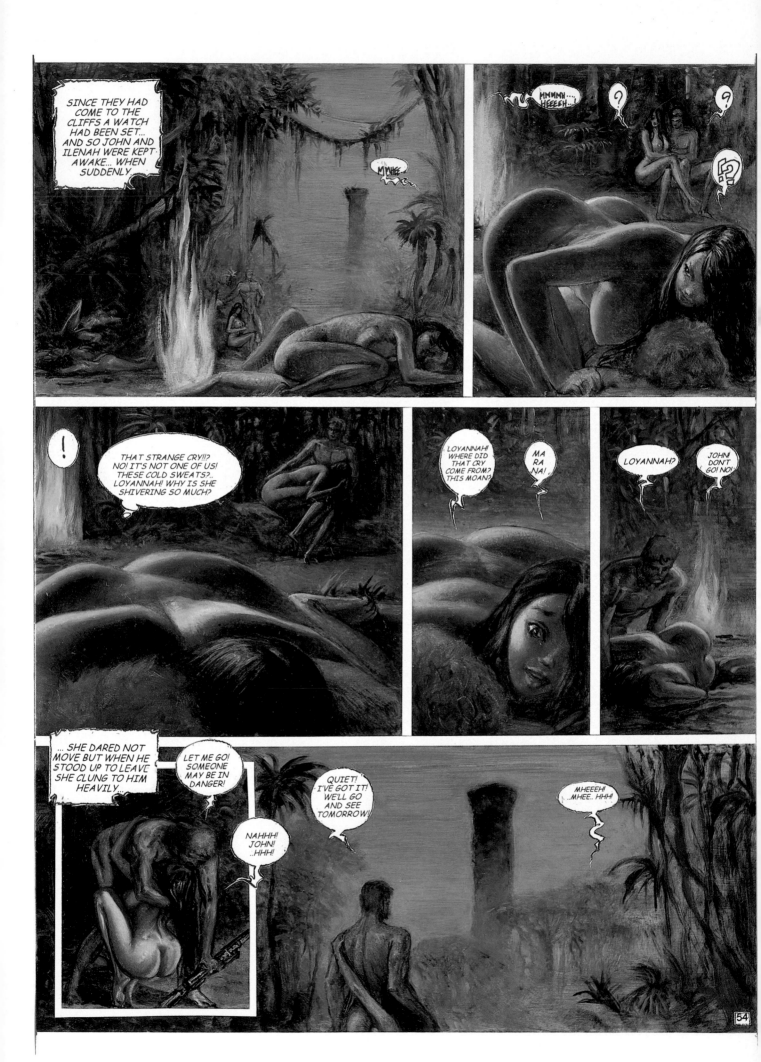

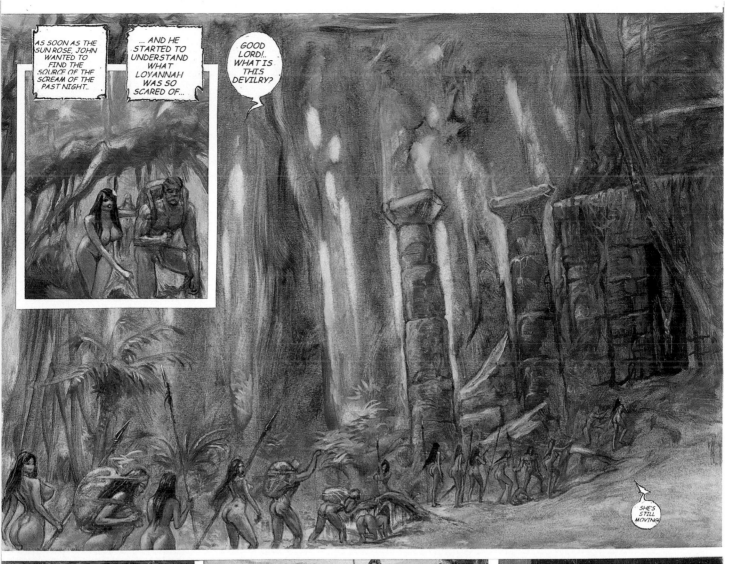

AS SOON AS THE SUN ROSE, JOHN WANTED TO FIND THE SOURCE OF THE SCREAM OF THE PAST NIGHT..

... AND HE STARTED TO UNDERSTAND WHAT LOYANNAH WAS SO SCARED OF...

GOOD LORD!.. WHAT IS THIS DEVILRY?

SHE'S STILL MOVING!

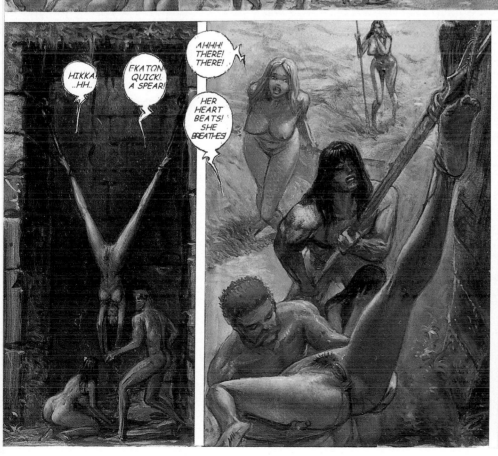

HIKKA! ..HH..

FKATON! QUICK! A SPEAR!

AHHH! THERE! THERE!

HER HEART BEATS! SHE BREATHES!

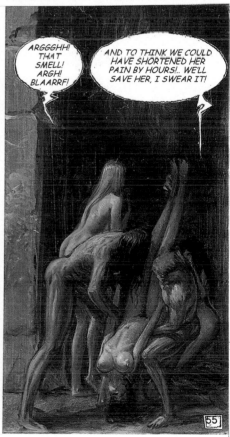

ARGGGHH! THAT SMELL! ARGH! BLAARRF!

AND TO THINK WE COULD HAVE SHORTENED HER PAIN BY HOURS!.. WE'LL SAVE HER, I SWEAR IT!

55

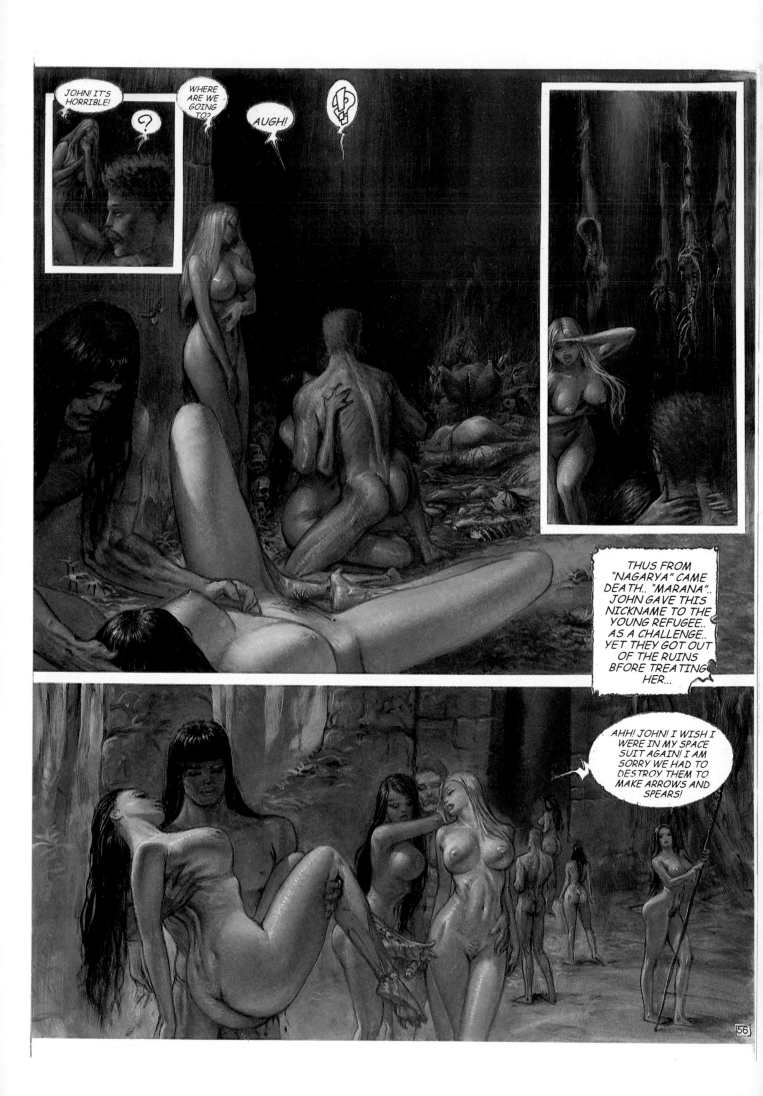

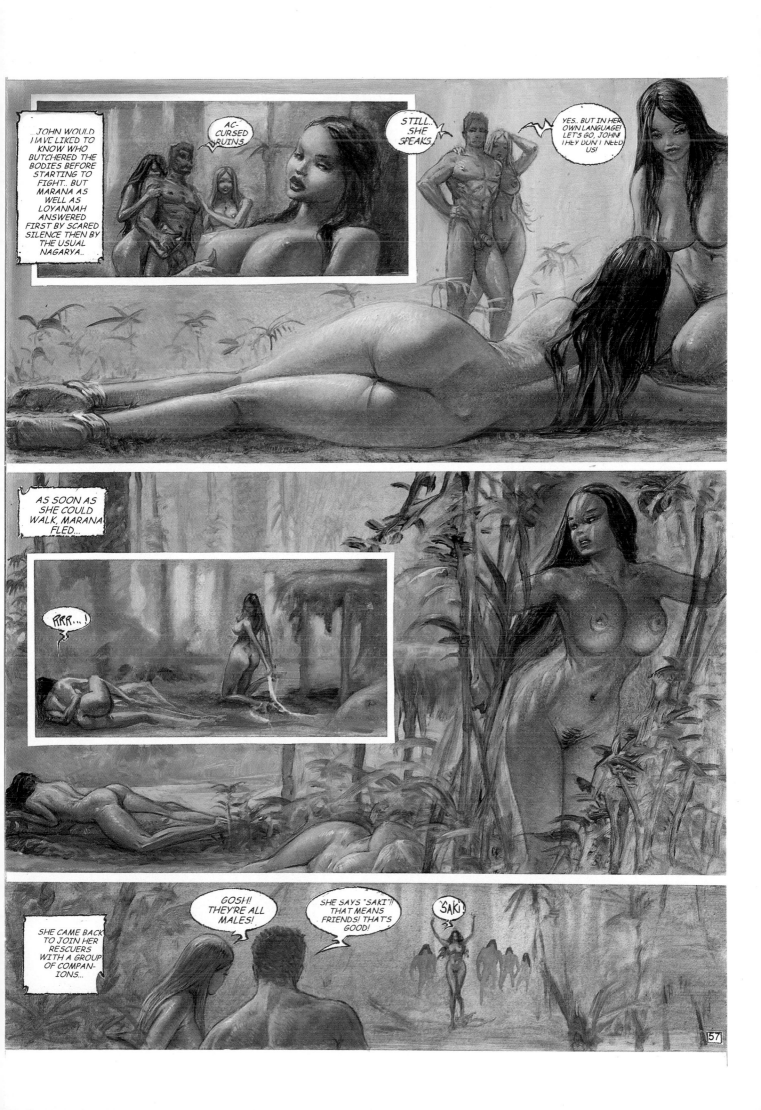

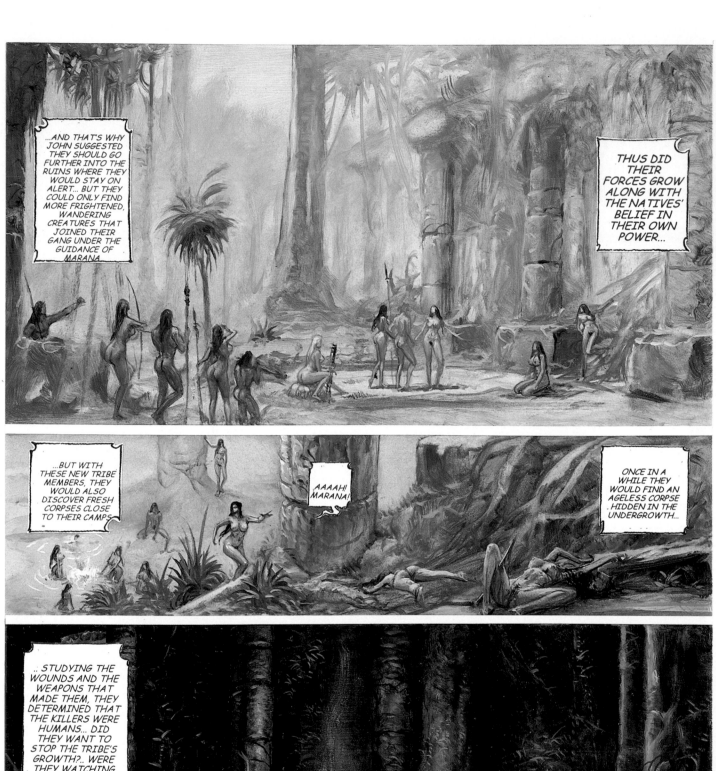

...AND THAT'S WHY JOHN SUGGESTED THEY SHOULD GO FURTHER INTO THE RUINS WHERE THEY WOULD STAY ON ALERT... BUT THEY COULD ONLY FIND MORE FRIGHTENED, WANDERING CREATURES THAT JOINED THEIR GANG UNDER THE GUIDANCE OF MARANA.

THUS DID THEIR FORCES GROW ALONG WITH THE NATIVES' BELIEF IN THEIR OWN POWER...

...BUT WITH THESE NEW TRIBE MEMBERS, THEY WOULD ALSO DISCOVER FRESH CORPSES CLOSE TO THEIR CAMPS...

AAAAH! MARANA!

ONCE IN A WHILE THEY WOULD FIND AN AGELESS CORPSE HIDDEN IN THE UNDERGROWTH...

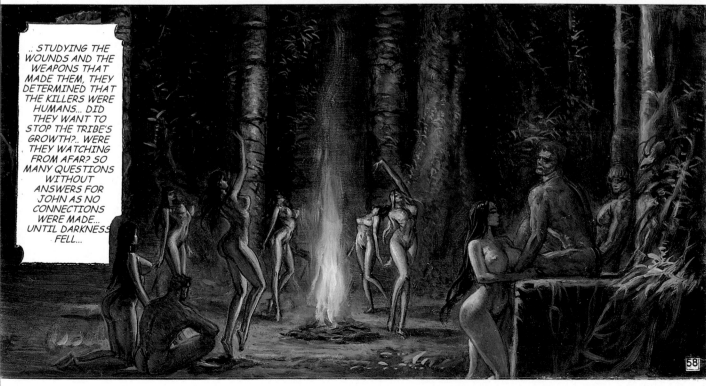

.. STUDYING THE WOUNDS AND THE WEAPONS THAT MADE THEM, THEY DETERMINED THAT THE KILLERS WERE HUMANS... DID THEY WANT TO STOP THE TRIBE'S GROWTH?.. WERE THEY WATCHING FROM AFAR? SO MANY QUESTIONS WITHOUT ANSWERS FOR JOHN AS NO CONNECTIONS WERE MADE... UNTIL DARKNESS FELL...

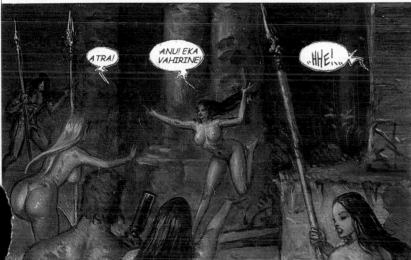

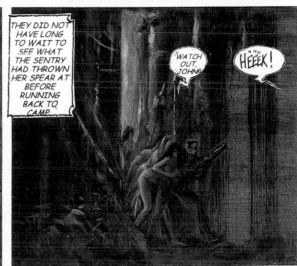

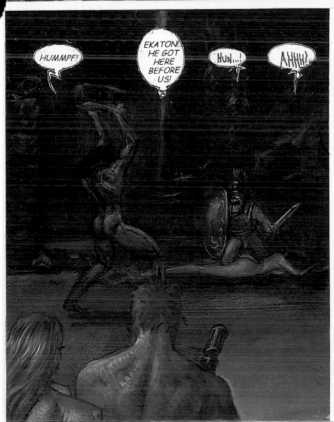

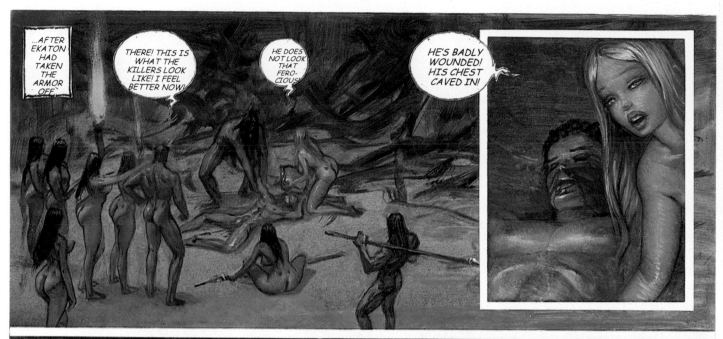

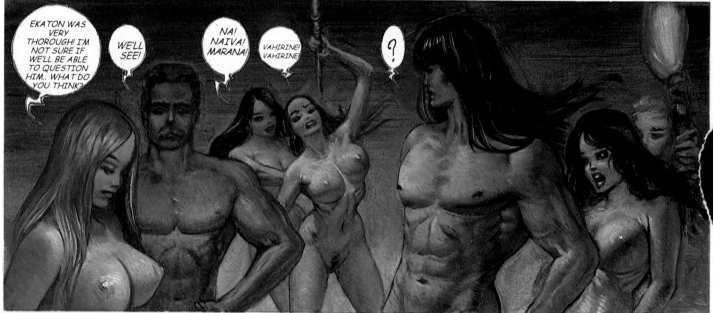

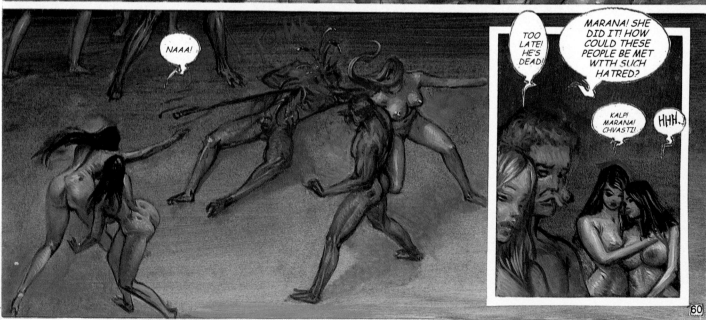

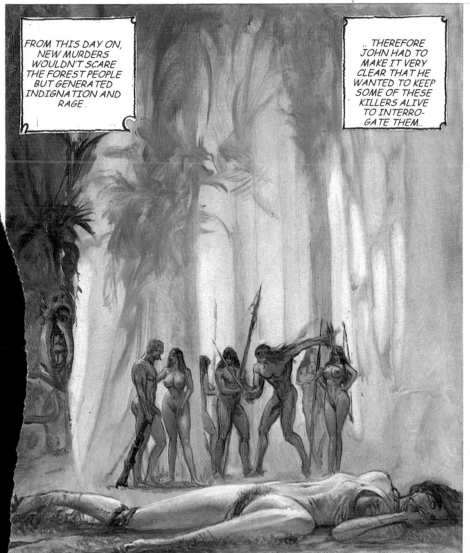

FROM THIS DAY ON, NEW MURDERS WOULDN'T SCARE THE FOREST PEOPLE BUT GENERATED INDIGNATION AND RAGE.

.. THEREFORE JOHN HAD TO MAKE IT VERY CLEAR THAT HE WANTED TO KEEP SOME OF THESE KILLERS ALIVE TO INTERRO-GATE THEM..

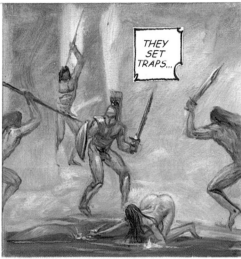

THEY SET TRAPS...

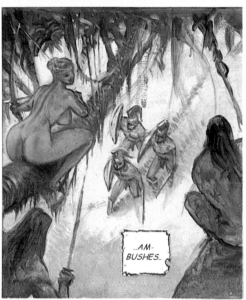

..AM-BUSHES..

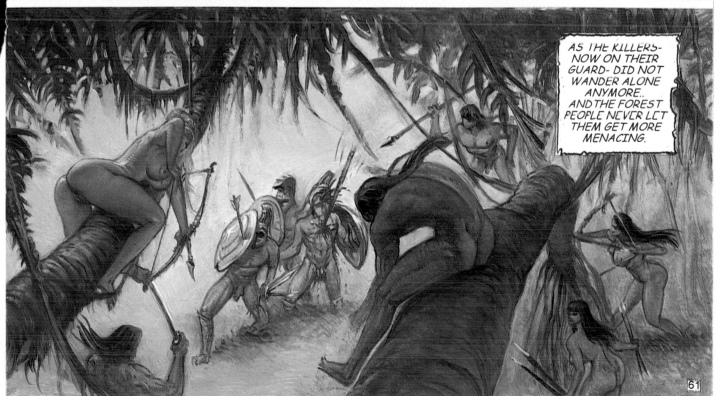

AS THE KILLERS-NOW ON THEIR GUARD- DID NOT WANDER ALONE ANYMORE.. AND THE FOREST PEOPLE NEVER LET THEM GET MORE MENACING.

61

THE END

NAGARYA Part 2: The Lost Continent

ISBN 0-86719-468-5

Published in the United States by
**Last Gasp of San Francisco P.O. Box 410067
San Francisco, Ca 94141-0067**

Copyright © **1998 Last Gasp**

Translated by Georgina Ranuzzi
Printed in Spain